HIDDEN HISTORY
OF THE
BOSTON
IRISH

HIDDEN HISTORY
OF THE
BOSTON IRISH

Little-Known Stories from Ireland's
"Next Parish Over"

PETER F. STEVENS

Charleston London
THE
History
PRESS

Published by The History Press
Charleston, SC 29403
www.historypress.net

Cover design by Marshall Hudson.

First published 2008
Second printing 2008
Third printing 2009

Manufactured in the United States

ISBN 978.1.59629.450.9

Library of Congress Cataloging-in-Publication Data

Stevens, Peter F.
Hidden history of the Boston Irish : little-known stories from Ireland's "next parish over" /
Peter Stevens.
p. cm.
ISBN 978-1-59629-450-9
1. Irish Americans--Massachusetts--Boston--Biography--Anecdotes. 2. Irish Americans-
-Massachusetts--Boston--History--Anecdotes. 3. Boston (Mass.)--History--Anecdotes. 4.
Boston (Mass.)--Biography--Anecdotes. 5. Boston (Mass.)--Ethnic relations--History--
Anecdotes. I. Title.
F73.9.I6S74 2008
974.4'610049162--dc22

2008001936

Notice: The information in this book is true and complete to the best of our knowledge. It is
offered without guarantee on the part of the author or The History Press. The author and
The History Press disclaim all liability in connection with the use of this book.

Contents

CONTENTS

Acknowledgements

This book is a compilation and expansion of columns I have contributed to the *Boston Irish Reporter* over the past decade. As a writer and editor for the newspaper, I have the privilege of working with publisher Ed Forry, editor Bill Forry and editor Tom Mulvoy, three of the best in the business and three of the best friends anyone can have. All have given me free rein to write about topics that have often fallen between history's proverbial cracks. I also had the rare privilege of calling the late Mary Forry—Ed's wife and co-publisher, a gifted writer and one of the bravest souls I've ever encountered—my friend.

No one can set out to write about the Boston Irish without calling upon the peerless and prolific author Professor Thomas H. O'Connor, professor of history emeritus at Boston College. His work *The Boston Irish: A Political History* stands as a benchmark of Boston Irish history. Also at Boston College, Professor Bob O'Neill has for years opened up the Burns Library's splendid Irish collections to me on this and many other projects.

Authors Mike Quinlin—founder of Boston's Irish Heritage Trail—and Dennis P. Ryan have delved into the city's vibrant and oft-controversial past to preserve the story of the Irish in these parts.

PART ONE

AND JUSTICE FOR ALL?

"Your Eyes Are Full of Murder"

Dominic Daley and James Halligan

On March 19, 1984, Governor Michael Dukakis officially proclaimed two immigrants innocent of murder. Their names were not Sacco and Vanzetti, but Daley and Halligan. For the Irishmen, justice arrived too late—nearly 177 years after Daley and Halligan were hanged in Northampton, Massachusetts, for a crime they did not commit. Arrest, a sham trial and the noose sealed the fates of Daley and Halligan, whose only crimes were being Irish in the wrong place at the wrong time. That place was Massachusetts in the fall of 1805.

On November 5, 1805, a horse galloped with an empty saddle along the Boston Post Road near Wilbraham. A local man settled the mount down and began to search in the direction from which the horse had materialized. The man halted just off the road and near a bend of the Chicopee River, where a body bobbed in the cold water.

Once local authorities fished the corpse from the river, they identified it as Marcus Lyon, a youthful farmer from Connecticut. A pistol ball had torn into his ribcage, and his killer or killers had "smashed his head to a pulp." As word of the savage murder spread throughout Western Massachusetts and across the New York and Connecticut borders, search parties tracked the Boston Post Road, fields and forests for "suspicious" men, especially strangers. The constables prowled the region for two burly men who looked like sailors and were headed toward New York, following the "sighting" provided by a local thirteen-year-old boy named Laertes Fuller, who claimed to have spotted the pair near the murder site.

Sometime in late 1805, a search party rode upon two men—thirty-four-year-old Dominic Daley and twenty-seven-year-old James Halligan—near

Rye, New York. The duo's brogues and rough appearance made them instantly suspicious to the constables. Daley and Halligan, however, "made no kind of resistance but professed innocence and willingness to be searched." The constables answered by throwing the Irishmen in chains and hauling the prisoners to a dark cell in Northampton.

Shortly after Daley and Halligan were imprisoned, local authorities escorted young Fuller into the jail for a look at the manacled suspects. The boy proclaimed them to be the very men he had seen fleeing from the purported crime scene.

For locals, mostly Protestant, an almost palpable sense of relief greeted Fuller's eyewitness identification. The fact that the alleged killers were Irish assuaged fears that one or more of the region's own native-born Protestant Americans had committed such a brutal act. As a Massachusetts jurist would later contend, locals preferred to believe that only "outsiders" could have killed so savagely, and in early nineteenth-century New England, Irish Catholic immigrants were the quintessential outsiders.

The authorities allowed no one except Special Prosecutor James Hooker of Springfield to visit Daley and Halligan until April 22, 1806. Only then, the day the Irishmen finally found themselves in the Northampton Courthouse and formally charged with the murder of Marcus Lyon, were the shackled suspects allowed the services of a defense counsel. Daley and Halligan immediately and vehemently entered a plea of innocence.

The court responded by allowing the prisoners all of forty-eight hours to prepare a defense with their court-appointed attorneys. The accused Irishmen's lead lawyer was Francis Blake, a Worcester barrister with no experience in capital cases. Similarly, no others among the defense team had ever argued a murder trial. Historian John T. Galvin notes, "The lawyers assigned had so little experience that they would not have been considered qualified to handle a capital case today."

The trial of Dominic Daley and James Halligan opened as scheduled at 9:00 a.m. on April 24, 1806, with Massachusetts Supreme Court Justices Samuel Sewall and Theodore Sedgwick on the bench. Sewall was a descendant of the Puritan judge who had dispensed justice during the Salem witch trials. In Sedgwick, the prisoners faced a jurist who in 1774 had espoused the inherent rights of all men in the Sheffield Declaration, but whose definition of "all" did not seem to extend to Irish Catholic immigrants.

Prosecuting the case was lawyer and politician-on-the-rise James Sullivan, no less a personage than the Massachusetts attorney general and a candidate for governor. Sullivan, his surname notwithstanding, had long espoused virulent anti-Irish and anti-Catholic dogma. In an election year, Sullivan's successful prosecution of two Irish murderers could vault him to the statehouse.

Because of the crowds that swarmed into Northampton for the trial, the judge moved it from the courthouse to the larger confines of the town meetinghouse. Twenty-four witnesses stood ready to link Daley and Halligan to the crime, a curious development, as there were no actual eyewitnesses; additionally, no physical evidence to link the Irishmen or anyone else to the battered body of Marcus Lyon would be presented.

Despite the lack of evidence, Blake knew that his clients' chances loomed as desperate at best, but nonexistent in reality. Sullivan intended to unleash an ethnic prosecution—Daley and Halligan's very Irishness, the attorney general believed, was proof positive of their propensity for such a vicious murder. Gutting the defendants' chances further, Massachusetts law in 1806 did not allow the accused to take the witness stand themselves. As Judge Robert Sullivan would write, "Until the law was changed in 1866, an accused was completely 'incompetent' to testify in Massachusetts."

From prosecutor Sullivan's opening remarks, the pattern of his case materialized with vicious clarity. He offered as evidence that "an Irishman"—not Daly or Halligan, but some unspecified Irishman—had bought a pistol in Boston and that "the pockets of the defendants were large enough to hold a gun." Of course the constables had found a pistol on neither man.

Daley and Halligan could do nothing but listen as Laertes Fuller described how he had seen the Irishmen "heading toward New York five months earlier," but could link them in no tangible way to the murder. Judge Sullivan would write, even "if one were to accept the boy's testimony as religiously true, it had no bearing on the crime itself." All that the youth could truly offer was that he had seen the two men striding along the Boston Post Road, just two among the many passersby along the route. The other witnesses, a collection of locals and constables, similarly offered little more than statements that the Irishmen, who had resisted arrest in no way, had looked suspicious.

When Francis Blake's turn came to argue the case, he assailed all of the prosecution's vague testimony. He closed with a diatribe against the real crux of the case: anti-Irish fervor. Blake railed at "the inveterate hostility against the people of that wretched country from which the prisoners have emigrated, for which the people of New England are peculiarly distinguished."

In his eloquent close, Blake intoned,

> *Pronounce then a verdict against them! Tell them that with all our boasted philanthropy, which embraces every circle on the habitable globe, we have yet no mercy for a wandering and expatriated fugitive from Ireland. That the name of an Irishman is, among us, but another name for a robber and*

an assassin; that every man's hand is lifted against him; that when a crime of unexampled atrocity is perpetuated among us, we look around for an Irishman...and that the moment he is accused, he is presumed to be guilty.

With a paucity of evidence and only the defendants' nationality to drive the prosecution's case, the trial lasted only one day, closing down at 10:00 p.m.

Theodore Sedgwick instructed the jury, "If you believe the witness [Laertes Fuller], you must return a verdict of conviction." The jury believed him as one of their own and took just a few minutes to return a "guilty" verdict.

On the following morning, April 25, 1806, Sedgwick sentenced Dominic Daley and James Halligan to the noose and their corpses to be "dissected and anatomized." The convicted men soon wrote a final, desperate plea for deliverance to Father Jean Lefebvre de Cheverus, who tended to Boston's still small but growing community of Irish Catholics. The condemned prisoners pleaded, "Come to our assistance."

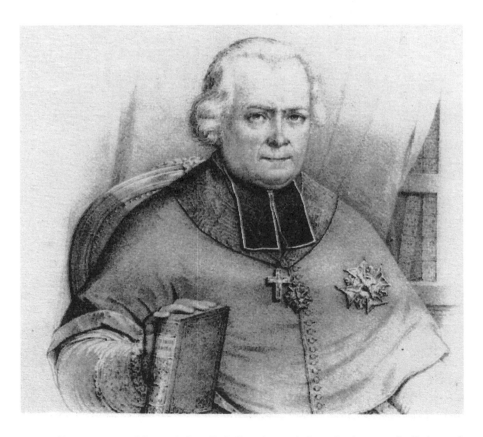

Father Cheverus, one of Boston's first Catholic priests, tried to win clemency for Daley and Halligan. *Library of Congress.*

Also begging for mercy was Mrs. Ann Daley, the mother of Dominic. She beseeched Governor Caleb Strong to pardon her son and his friend on grounds that the evidence was weak and hinged on a thirteen-year-old's testimony. She wrote, "Neither can your excellency be unconscious of the prejudice prevailing among the inhabitants of the interior against the common Irish people and, in the present case, the public mind has been influenced to a great degree by conversations and newspaper publications which precluded the possibility of that impartiality of trial which the law contemplates."

Governor Strong turned down Ann Daley's plea.

Resigned to the prisoners' fate and determined to bring them what comfort still existed, Father Cheverus rode to Northampton to minister to Daley and Halligan in the days before their date on the scaffold. At Pomeroy's Tavern in Northampton, the innkeeper and his wife refused the priest because the woman "would not have been able to sleep a wink under the same roof with a Catholic priest." Accordingly, Father Cheverus stayed at the jail until a braver local named Joseph Clarke provided a room at his home for the priest.

Up to and on the day of the hangings, Father Cheverus visited the condemned and provided Communion. He also heard their last confessions,

The petition by Ann Daley, the mother of falsely convicted murderer Dominic Daley, to Governor Caleb Strong for mercy for her son. *Massachusetts State Archives.*

and while he would never violate the priest-penitent confidence, he would always state that Daley and Halligan were innocent of the murder.

Local Protestant clergy tried but failed to prevent Father Cheverus from addressing the throng gathered for the executions. The priest became enraged when he saw the crowd that had gathered to watch Daley and Halligan die. "Whosoever hateth his brother is a murderer," he exclaimed, "animated with holy indignation against the curiosity which had attracted to the mournful scene such a crowd of spectators."

Cheverus was particularly dismayed at the many women in the crowd. "I blush for you," he said. "Your eyes are full of murder."

On that April morning in Northampton, a town of about 2,500 people, over 1,500 men, women and children ringed the scaffold upon which Dominic Daley and James Halligan were dispatched by their nooses in "a fearful dance of death." The site of the hanging was on the future grounds of Northampton State Hospital.

Many years later, long after the death of Father Cheverus, who had risen to become a bishop, a Western Massachusetts man reportedly made a "deathbed confession" to the murder of Marcus Lyon. The killer was the uncle of Laertes Fuller, whose "identification" had doomed two innocent Irishmen to the gallows.

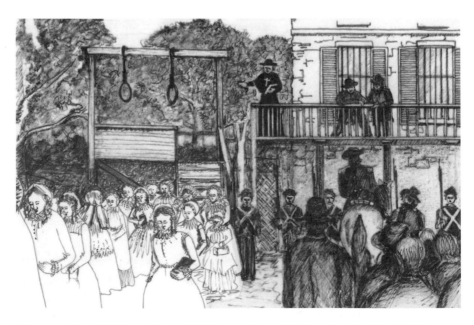

The execution of Irishmen Dominic Daley and James Halligan (top right) in 1806 for a murder they did not commit. *Drawing of Daley and Halligan at the gallows on Pancake Plain in Northampton, Massachusetts, by David Bourbeau, 1995, Historic Northampton Museum.*

"The Fires of Hate"

The Burning of Charlestown's Ursuline Convent

The missive's message radiated menace:

> *To the Selectmen of Charlestown!*
> *Gentlemen—It is currently reported that a mysterious affair has lately happened at the Nunery [sic] in Charlestown. Now it is your duty, gentlemen, to have this affair investigated immediately; if not the Truckmen of Boston will demolish the Nunery Thursday night—August 14.*
> *Boston, August 9, 1834.*

The "mysterious affair" that the handbill referred to was that of Sister Mary John, a young nun at Charlestown's Ursuline Convent. On July 28, 1834, she had lurched in a daze from the convent, showed up at a nearby home and had soon been returned to the convent, where she was eventually calmed down through the ministrations of her fellow sisters. The nun's moodiness and unstable behavior had long concerned Mother Superior St. George, who was in charge of the convent, but she had never imagined the young woman's problems would ignite tensions between the local Irish and Yankees further than ever.

With Boston's anti-Catholic, anti-Irish fervor simmering from rumors of "Popish plots" and from inflammatory books and articles warning that "ragged Irish Papists" would destroy Anglo-America, many locals imagined something sinister behind Sister Mary John's "ordeal." Chief among such rumors abounded wild falsehoods of "deviant" behavior and secret, bloody rituals behind the walls of the convent.

The warning that Yankee workmen would destroy the convent unless authorities uncovered the "real" reason for Sister Mary John's odd behavior and her "forced" return to the convent unnerved Boston Catholic Bishop Benedict Fenwick and various politicians alike. Antipathy between local Irish Catholics and Boston Protestants had never run higher, and for the latter, the graceful, three-story brick convent, less than seven years old and perched on a Charlestown slope close to Bunker Hill, symbolized the inroads of the growing Irish community so threatening to many Bostonians. Ironically, however, many of the girls studying and boarding at the convent's school hailed from prominent Protestant families who considered the Ursulines' all-female academy as the best in the region.

Tensions surrounding the school swelled further with another handbill plastered across Boston and Charlestown a day later: "Go ahead! To arms! To arms! Ye brave and free, the Avenging Sword unshield! Leave not one stone upon another of this cursed nunnery that prostitutes female virtue and liberty under the garb of holy Religion. When Bonaparte opened the Nunnerys of Europe, he found crowds of Infant skulls!"

Though it is hard to comprehend in modern times, such fraudulent notions carried great weight to New Englanders raised on centuries of religious fears toward Catholics reared in equal measure to dread Protestants.

Charlestown Selectman Samuel Poor, claiming he wanted to settle Boston's latest religious contretemps, the Sister Mary John story, rapped

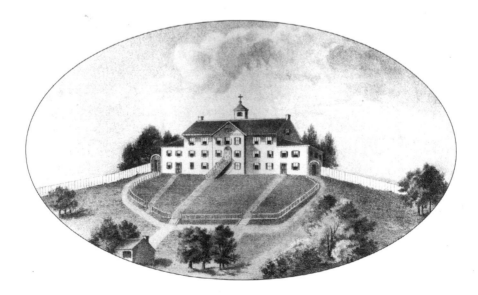

The Ursuline Convent and school on Mount Benedict, Charlestown. *Gleason's Pictorial Companion.*

on the convent's door on Sunday, August 10, 1834. He showed Mother Superior St. George the second handbill, and urged her to "explain" Sister Mary John's erratic demeanor. Poor later claimed, "She treated the information [in the handbill] with indifference and contempt, and she said she did not care a straw about it…Her own innocence would protect her."

That the mother superior would dismiss the handbill's lies with contempt should have surprised no one. According to Poor, though, St. George added verbal vitriol: "She also said that she could send her own man [the convent caretaker] to the railroad, and *raise five hundred Irishmen in fifteen minutes*, and the Bishop could raise twenty thousand Irishmen" to defend the convent.

Despite her "threat," she permitted Poor and Charlestown's other selectmen to inspect the convent the next afternoon for any signs of abuse or aberrant behavior. She allowed the centerpiece of the controversy—Sister Mary John herself—to take the officials on a room-by-room search of the building. The Protestant politicians found nothing amiss and pledged to report to the Boston newspapers that all was above board at the nunnery. Neither Poor and company nor the mother superior yet realized that it was already too late, for the "Truckmen's" (Yankee wagon drivers and other workmen) rage against Irish Catholics seeking a new life in Boston and environs had irrevocably targeted the convent.

By 8:00 p.m. on August 11, 1834, a mob of Yankee workmen gathered in front of the convent's gateway. Anti-Irish, anti-Catholic epithets filled the evening air. Typifying the throng's ugly mood, one workman spat, "If the Catholics get the upper hand of us, they will crush us to the earth." Another added that "the convent would come down." Torches brandished throughout the mob reflected the timbre of the rioters' words.

Striding in the forefront of the crowd, which was up to several hundred strong, was any Boston Irishman's worst nightmare—John Buzzell. Twenty-nine years old, six feet, six inches of rawboned muscle, the New Hampshire–born bricklayer had honed a fearful reputation for pummeling Irishmen in brawls throughout Boston.

At 9:30 p.m., Buzzell led the mob up the winding carriageway to the convent door, cries to torch the building pealing everywhere. Mother Superior St. George met Buzzell and ordered him to depart with the others. Amazingly, the nun's imperious courage sent Buzzell and company back to the street outside the convent fence—but not for long.

The mob soon surged at the convent again. Sister Mary Bernard, an Irish immigrant formerly named Grace O'Boyle, leaned from a window and implored the workmen to leave them alone. For a moment, her earnest appeal seemed to have an effect. Then the mother superior threw open another window, ordered the "drunkards" to leave and lit the proverbial fuse with her remonstrances.

18

At 11:30 p.m., Buzzell and his boys, torches in hand, stormed into the convent. In their one act of humanity that night, they combed each room to make sure that neither nuns nor young students remained. They did not—the mother superior and her nuns had evacuated their sobbing students to a "summer house" at the rim of the convent grounds.

Shattering windows and furniture on each floor of the convent, ransacking every desk and cupboard, swearing and laughing, the mob reveled "in the spirit of deviltry." Some danced around in nuns' robes seized from the closets; several found a cache of Communion wafers and tossed them everywhere. In an especially horrifying scene, a band of workers broke into the mausoleum on the grounds, pried off nameplates on coffins and bashed open one of the caskets to leave the remains exposed.

Flames erupted from every corner of the convent at 12:30 a.m., just an hour or so after the mob stormed into the building. Fire bells pealed across the city, and the engine companies—Yankees all—dispatched "water wagons" and crews to the blazing convent. Once there, they did nothing but watch the blaze. The convent was a charred ruin by sunrise.

Despite public outrage from Yankee politicians and clerics and despite prosecutors' promises of punishment for the mob, the local Irish knew better. Buzzell and eleven of his fellow incendiaries were indicted and stood

The Ursuline Convent in ruins after a Yankee mob torched it in 1834. *Gleason's Pictorial Companion*.

trial three times from December 1834 to June 1835. "The defense attorneys effectively exploited anti-Catholic feeling, which was their trump card," to win acquittals for Buzzell and ten others. Only a youth named Marvin Marcy was found guilty, and he was pardoned within a year.

The outraged Irish heeded Bishop Fenwick's appeals not to retaliate. The *Boston Galaxy* acknowledged, "The Irish population have been remarkably orderly and quiet."

In their collective memory, the Irish population's thoughts simmered with little order and quiet. The flames of August 1834 burned not only Charlestown's Ursuline Convent, but also the very soul of Boston's Irish community. For generations, the convent burning remained a cultural, political and religious flashpoint, tangible proof of the obstacles the Boston Irish would have to overcome.

Sworn to Secrecy

The "Know-Nothing" Papers

On October 13, 1854, a group of men met somewhere in Boston—in secret. They shared a common bond of prejudice against Catholic immigrants. A member of that band, the self-styled RLG (Republican Liberty Guard), recorded their oath and secret signs, as well as their ethnic and religious biases.

Part of the "Know-Nothing Party," or the American Party, they had evolved in the Nativist movement, which had hardened many "native-born" Americans—with no shortage of Boston Brahmins and Yankees—against the "threat" posed by foreigners, particularly Irish Catholic immigrants. In Boston, the "Broad Street Riot," which pitted Irishmen and Protestant firemen against each other, and the infamous burning of Charlestown's Ursuline Convent owed much to Nativist hatred.

The Know-Nothing movement had become entrenched in Massachusetts in the early 1850s, in large part because of the wave of Irish immigration. "Native-born" Americans filled the state Senate, and all but four seats in the House of Representatives. Massachusetts's governor? Henry J. Gardner, a Know-Nothing. Boston's mayor? Jerome VanCrowninshield Smith, who loathed Irish Catholics.

Despite the party's prominence in Massachusetts of the day, little of their "inner doings"—the manner in which they met, the way they ran their meetings and the way in which they issued their oaths and passwords—would survive. That has all changed, courtesy of a rare document now housed in Boston College's Burns Library.

The document, five pages of light blue paper whose ink is quite legible, if faded in a few spots, speaks volumes about the distrust and outright

prejudice encountered by the Boston Irish. The fact that the pages came from a secret Know-Nothing meeting in Boston makes Boston College's Nativist manuscript a powerful historical artifact of the region's past.

The document was acquired by Robert O'Neill, director of the Burns Library. "I hadn't seen anything like this," Professor O'Neill said. "It's the first time I'm aware of that a document of this type [recording an actual Know-Nothing meeting] has surfaced."

O'Neill purchased the aged blue pages from Stewart Lutz, whose company, Princeton Historic Documents, deals largely with historical and literary manuscripts. Lutz discovered the Nativist pages in a box of other materials he had just bought, and when he saw the word "Boston" and the Nativist themes, he contacted O'Neill. On reading it, O'Neill found that it "was consistent with what we know of the nativist and Know-Nothing movement." He immediately brought the pages to Professor Thomas O'Connor, author of *The Boston Irish: A Political History* and *Boston Catholics* and university historian at Boston College. O'Connor quickly agreed that the manuscript was the genuine article, the ink and paper dating to the 1850s.

While there was "no real detective story" in the document's acquisition, O'Neill said that it does help pierce "the extraordinary secrecy" of the party, whose members were sworn to answer any questions from "outsiders" with three words: "I know nothing."

The five 7½- by 9¾-inch pieces of old blue notepaper ensure that historians and anyone with Boston Irish roots alike will know more about the nativists who once ruled the state legislature. Above the emblem of "Old Glory" and the American eagle on the first page is emblazoned the bold line "Put None but American on Guard!" To the Boston men assembled for the October 13, 1854 meeting, no immigrant or Catholic was a "real American."

The meeting's minutes offer a litany of biases, oaths and paranoia about "nonmembers." The words speak for themselves—hidden away for nearly 150 years:

> *Opening of Meeting The Highest Officer…of such Company shall call it to order. He shall then station Guards at the doors. The inner Guard will see that no one's admitted without the countersign. The outer Guard will admit no one without the password, except those to be initiated.*
>
> *The President's Officer shall then order one or more comrades to ascertain if all in the room have the countersign and the password. If there are any persons present who have not the countersign and password they must be vouched for as members of the Order in good standing or retire.*

Faded pages of the only extant oaths and minutes of a Nativist—anti-Irish, anti-immigrant, anti-Catholic—Party meeting. *Burns Library, Boston College.*

The comrades having completed their examination will advance to the center of the room before the Commanding Officer and report Alls Well! (They will then be seated)
 The Commanding Officer will then command Attention at which all the comrades will rise, He will then command Salute!

For perhaps the first time since the last Know-Nothings carried their "sign language" to the grave, the Boston College document reveals a secret salute: "All the comrades will salute the Presiding Officer by raising the right hand to the side of the head—placing the ball of the thumb at the bottom of the two middle fingers, the lower joint of the fore finger resting against the cheek bone. All will then be seated and the meeting declared open for business."

One order of business was to examine "any persons in waiting to be initiated." An officer would then "examine the candidates…and ask…the following questions." The questions were intended to judge a man's anti-immigrant, anti-Catholic convictions, as well as his commitment to secrecy.

The officer would ask, "Will you pledge yourself to honor to keep secret all the question that may be asked you and all the information you may receive in this room?"

"Ans[wer] I will."

"Are you above the age of 18 years?"

"Ans[wer] I am!"

Now, the "novices" stood ready for the next step: initiation into the Know-Nothings. They were led in front of "the Commanding Officer" after another officer deemed them "strangers in waiting duly qualified who desire to become our comrades." The commanding officer intoned,

> *Gentlemen; the organization of the present Military force of this country, both regular and volunteer is such that large bodies of men of foreign birth are and can be enrolled not only in separate bodies, but to a greater or less extent in nearly every corps of Citizen Soldiery, thereby basely contaminating the Institution by placing arms and power in the hands of men who though enjoying the benefit of our laws cannot be relied upon in the hour of danger, are foes to civil and religious liberty, acknowledging as they do a higher authority in the person of the Pope of Rome than any civil or military powers in this Republic.*

Heaping further revulsion upon Catholics and immigrants in Boston, "Irish" was virtually synonymous with both. The Know-Nothing officer invoked George Washington in a garbled "justification" for Nativism: "We have been admonished by the example of our immortal Washington to Put none but Americans on Guard, and by his precept to beware of the wiles of foreign influence."

Contempt for and fear of "foreigners" further simmers in the officer's exhortation to "defend our Republican Institutions against the encroachments of the Church of Rome, its Popes Cardinals Priests and its ignorant and deluded followers."

The moment of initiation loomed, the moment when the candidates were informed that "we are associated in a secret Military Order."

The Boston group's leader instructed the new recruits: "Raise your right hand up before the floating flag of your country, place your right foot on the emblem of the Church of Rome." Then the men swore the Boston chapter's oath, the words of which would remain hidden until they resurfaced first in Stewart Lutz's box of documents and then at the Burns Library. Even today, the zealotry of the nativists emerges in each word of that oath:

> *I* [name] *solemnly pledge my honor as a man in the presence of Almighty God and these witnesses that I will do all in my power to carry out the object of this Institution as they have been explained to me. That I will keep secret all initiation pass words and countersigns and other private matters of the Order. That I will go to the assistance of a comrade attacked by foreigners should I hear his signal and render him all the aid in my power. I will consider this obligation binding to the end of life.*

The commander ordered the men to lower their hands and announced, "I now welcome you as comrades in the RLG [Republican Liberty Guard]." He then shook each man's hand.

For the new members, there was another order of business: the "countersign and passwords." All of them were revealed to the men in a whisper. The recognition sign "on meeting an individual supposed to be a comrade" was to "place your right thumb in your right vest pocket"; if the other man responded by placing his left thumb in his left vest pocket, an RLG member was to "advance and take him by the hand without shaking it."

Next, the first man would say, "On what hill," and receive the answer, "Bunker Hill."

In 1856, the American Party ran Millard Fillmore in the presidential election. While the men of the Boston Republican Liberty Guard likely cast their ballots for him, he won but one state, Maryland. The onset of the Civil War would shove the Know-Nothings into history's backwaters. Still, antipathy toward immigrants would endure. The five Nativist pages in the Burns Library bear testimony to an era when Boston's Irish were viewed as a threat to "real Americans."

PART TWO
UNREPENTANT REBELS

A Bold Fenian Man

John Edward Kelly

On a blustery November Monday in 1885, a crowd gathered at Mount Hope Cemetery near Boston. Surrounding a granite monument cut in the configurations of an Irish round tower, they fell silent as a jut-jawed man with a bristling mustache began to speak. John Boyle O'Reilly, renowned writer, poet, editor, orator and Boston Irish "mover and shaker," had arrived at Mount Hope to praise the Irishman "who sleeps under the monument." O'Reilly was paying homage to fellow rebel John Edward Kelly, an immigrant who, like O'Reilly, had been one of the 1860s' "bold Fenian men."

Many Boston Irishmen of the day shared the surname of John Edward Kelly, but few had sacrificed so much for their beleaguered homeland. O'Reilly noted, "We have come together today for the purpose of honoring the memory of a man who was found true in a day of supreme trial…[and] gave example of the virtues of courage, fidelity, and sacrifice."

Although Kelly had passed away in January 1884 at only thirty-five, he had lived far longer then he had anticipated. For shortly after his capture at Kilclooney Wood in the ill-fated Fenian rising of 1867, rifle still in hand, he had been sentenced to a "traitor's" death—to be "hanged, drawn, and quartered" by the British.

Until the ceremony at Mount Hope and O'Reilly's eulogy, few Boston Irish who passed Kelly in the streets would have noticed anything extraordinary about him. He had first stepped onto the city's waterfront in the early 1870s, a free man for the first time in five years. How he escaped the gruesome sentence handed down by a British magistrate and how his path had led to

Boston were largely unknown in his adopted city. Now, in the November chill of 1885, another Fenian revealed the unsung rebel's story.

John Edward Kelly's saga began in Kinsale, Ireland, with his birth to a family of "modest means" in 1849. Somewhat fittingly, the future rebel's birthplace near the banks of the River Lee had been the site of a crushing defeat for Hugh O'Neill and Red Hugh O'Donnell on Christmas Eve of 1601, effectively ending their long revolt against the English. The ruins of a war-battered fortress shadowed the landscape of young Kelly's town.

As a youth, Kelly was swept up in the Fenian movement, which was organized in Ireland and the United States in 1858 and whose members were bound by a secret oath to create an Irish Republic—by any means necessary. The Fenian Brotherhood, under the leadership of John O'Mahony in America, merged with Kilkenny-born James Stephens's Irish Republican Brotherhood to foment a rebellion. In the 1860s, the Fenians, who adopted their name from the ancient Irish military corps that had served third-century high kings and figured prominently in the legends of Finn Mac Cumhil and Ossian, began smuggling arms and ammunition into Ireland. Rebellion drifted in men's thoughts from Cork to Ulster.

One young man who embraced the Fenian ideal and eagerly swore the movement's oath was nineteen-year-old John Edward Kelly. The cause for which Kelly was willing to die was doomed, riddled with informers and lacking the broad-based support necessary for even "a glimmer of chance." As rumors of revolt swelled into a coming reality, the Crown moved with its characteristic ruthless efficiency to crush it. In 1865, the British shut down the Fenians' newspaper, the *Irish People*, and arrested Stephens. He managed to flee to America. Inflicting further damage upon the Fenians' hopes was the official opposition of the Catholic Church, "which decried any violent revolt" and "doubtless kept many potential members from joining its [the Fenians] ranks."

By 1865, most of the movement's leaders in Ireland had been arrested or had fled. Still, in America, thousands of Irishmen who had learned the soldier's trade in the Civil War seethed with a desire to apply these lessons by driving the British from Ireland.

In Ireland, the remnants of the Fenians awaited some signal to rise. With no real hope of success, scattered bands of Fenians took up what weapons they had and rose in rebellion. As O'Reilly would remark in 1885, in the doomed Fenian vanguard stood John Edward Kelly. "Eighteen years ago, the moldering form under this tomb went out and faced the bayonets of the oppressor of his country in a fight of overwhelming odds. No matter now about the wisdom or the calculation of chances for success. The motive beneath the act was golden."

O'Reilly knew the truth of these words, for he, like young Kelly, had risked everything for the dream of freedom. As with Kelly, O'Reilly had been born in a place where the English had crushed Ireland's hopes. He hailed from Drogheda, where Cromwell's massacre of Catholic men, women and children still seemed to permeate the very soil of County Meath. O'Reilly, too, had dreamed of throwing off British rule and as a hussar in the Crown's army had converted other Irish soldiers into fellow Fenians. The British, however, discovered his "treason" and packed him off to a Fremantle gaol in western Australia. He made a hair-raising escape and turned up in Boston several years before Kelly.

In early March 1867, Kelly had marched with a ragtag band to Kilclooney Wood and faced British steel in a hopeless action. "The few men who went into open rebellion in Kilclooney Wood in 1867 were heroes as true in defeat as the world would have hailed them in success," O'Reilly would laud. "Side by side with Dr. Peter O'Neill Crowley [a Fenian leader], who was shot dead by an English bullet, John Edward Kelly, a youth of nineteen, was overpowered, rifle in hand, and was flung into prison."

Several months later, Kelly wished that he had fallen alongside Dr. Crowley. The youth was hauled into a courtroom "before an English judge, dealing out English law against a helpless enemy of England, and could do nothing but listen as he heard his own name attached to the abominable sentence...to be hanged, drawn, and quartered."

To the young rebel's certain relief, his death sentence was commuted, and he was clapped with sixty-one other Fenians aboard the convict ship *Hougoumont* and transported to remote, "escape-proof" Fremantle, which was flanked on one side by shark-infested waters and on the other sides by the lethal Australian bush. He was lucky to be alive, but condemned never to see his homeland again and to die in servitude.

Although Kelly would never return to Ireland, in 1871 he and other "civilian Fenians"—unlike the "soldier Fenians" of the British army—were released from prison but barred from ever heading back to Ireland. He eventually made his way to Boston.

On November, 23, 1885, nearly two years after John Kelly's death, John Boyle O'Reilly was determined to give his unsung compatriot a measure of immortality. "The highest honor that a man can bear in life or death is the scar of chain burns in a good cause," O'Reilly said. "Standing here by the grave of a man who lived and died humbly, modestly and poorly, we are not deceived by lowliness, by poverty, nor even by errors. We find that, after the sifting of death and years, there remains to us his courage and devotion."

In words evoking tears from many in the crowd and stoking memories of Ireland, O'Reilly intoned, "In his short life this man illustrated many phases

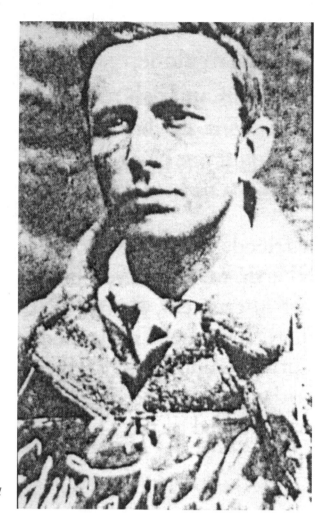

The prison photo of Irish rebel and later Bostonian John Edward Kelly. *National Archives, Dublin.*

of the Irish question. He left Ireland in his childhood, but the patriotic fire burned as strongly in exile…He was a Protestant in religion, but he was as true to Ireland as Wolfe Tone and the tens of thousands of living Irish Protestants who are Irish patriots. It is fitting that this stone should be erected to a dead rebel."

Despite O'Reilly's intent in 1885, John Edward Kelly's name would slip back out of public memory. In Mount Hope Cemetery, however, a granite marker in the shape of a round tower still testifies that a valiant rebel lies beneath it.

The round tower marker above John Edward Kelly's grave in Mount Hope Cemetery, Mattapan. *Harry Brett photo*, Boston Irish Reporter.

High-Seas Drama

Molly Osgood Childers and the *Asgard*

It holds a unique and pivotal place in Irish rebels' annals. It is the *Asgard*, a sleek Boston yacht that became Ireland's most famous gunrunner. Without the *Asgard*, the 1916 Easter Rising might never have materialized ninety years ago.

One might expect the vessel's tale to be of strong Boston Irish connections. The yacht, however, carried a solid Boston connection; its origins lay not in the city's Irish wards, but in the Brahmin bastion of Beacon Hill.

The *Asgard*'s saga began with the marriage of Boston socialite Molly Osgood, the daughter of one of Boston's most prominent surgeons, to Erskine Childers, author, ex-British officer and world-class yachtsman. He was a thin, meticulously groomed man whose face and bearing seemed haughty and aloof. His bride hailed from a class that typically treated the local Irish with contempt.

Few among Molly Osgood Childers's social set would have envisioned her husband standing in a photograph alongside Michael Collins, Arthur Griffith and other Irish nationalists, yet, in a group shot of the Irish delegates during the controversial treaty talks, Childers literally appeared behind the shoulder of Collins himself, the rebel whose name elicited rage among Molly's former Beacon Hill friends.

Although Childers achieved a bit of literary immortality with his seagoing thriller *The Riddle of the Sands*, his chief fame would come in a real-life maritime feat and pivotal event for Ireland. The vehicle for the exploit was a wedding gift. Molly Osgood's parents, well aware of their son-in-law's passion for sailing, had commissioned a gifted shipbuilder in Larvik,

Norway, to build the couple a world-class yacht. Named the *Asgard*, after the mythical residence of the ancient Norse gods and of Vikings slain in battle, the fifty-one-foot-long ketch could navigate open ocean and narrow coastal inlets with equal ease. For a talented sailor such as Erskine Childers, the *Asgard* offered a perfect blend of natural form and function. For a would-be-gunrunner, the ketch's speed and maneuverability were equally ideal for losing pursuers in a squall or along a shoreline. Erskine and Molly Childers embraced the prospect.

Molly Osgood Childers shared her husband's love of the sea and had become such a fine sailor herself that she often took the *Asgard*'s helm. In July 1914, with Europe a proverbial powder keg ready to erupt into World War I, the Childerses tacked the *Asgard* into waters off the Belgian coast and rendezvoused with another vessel, a German tug with some 1,500 rifles and at least 45,000 rounds of ammunition. A second yacht, the *Kelpie*, had arrived with the *Asgard*.

The crews crammed nine hundred rifles and crates of bullets into the hold of Childers's craft and the rest aboard the *Kelpie*. Both yachts set course for Ireland without benefit of radios or any power except that of sail. Off the coast of Wales, the *Kelpie* transferred her lethal cargo to another yacht, the *Chotah*, for the final run to the Irish coast.

On Sunday, July 26, the sixteenth day of the *Asgard*'s voyage, she and the *Chotah* dropped anchor off Howth, on the northern rim of Dublin Bay. Waiting on the jetty were up to a thousand National Volunteers and a fleet of taxis. The *Asgard* had slipped into the bay right on time and right under the nose of the Royal Navy.

The volunteers and the crew, Molly Osgood Childers included, unloaded the German rifles and crates of ammunition from the yachts to the taxis in a mere half hour. As volunteers lugged away the rest on their backs and shoulders, the *Asgard* and the *Chotah* sailed from the bay before any British vessels could intercept them.

Although they were outdated compared to the rifles of the British army, the weapons smuggled aboard the *Asgard* would peal across Dublin during the Easter Rising. Without them, Padraig Pearse, Michael Collins, de Valera and the rest of the Irish Volunteers and the citizen army might have been unable to launch the fury of the 1916 Easter Rising and the rebellion that would follow.

Erskine Childers remained a key figure in Ireland's struggle for freedom, serving as one of the reluctant architects of the controversial treaty. By 1922, however, he was hated by both the British, who deemed him a traitor to the Crown, and by Ireland's Free State government, against which Childers sided with de Valera. On November 14, 1922, Childers

was captured by Free State forces, dragged in front of a military court and summarily sentenced to death. Before a legal appeal could be filed, he was shot; the man who had sailed in rifles for the rising was executed by his ex-comrades. Of the yachtsman and rebel, historian Giovanni Costigan lamented, "Perhaps the saddest episode of all was the vindictive killing of Erskine Childers, a most courageous and honorable man."

After her husband's death, Molly Osgood did not seek solace in the drawing rooms of Beacon Hill. She remained in Ireland until her death in 1964.

In 1961, three years before Molly Childers died, the ship that had literally launched the Bostonian and her husband to fame was falling apart in an English boatyard. When news of the craft's condition reached Dublin, the government purchased the *Asgard*. Erskine Childers's old comrade Eamon de Valera, the president of Ireland, promised Molly Childers "that the great

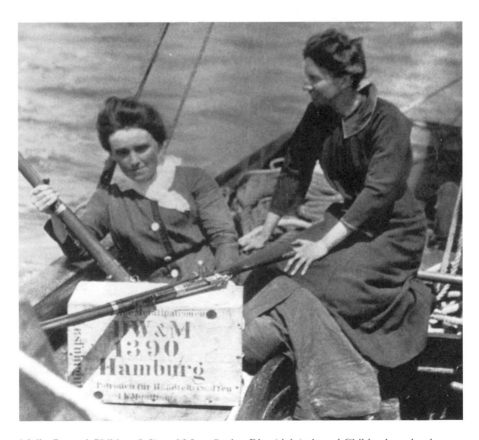

Molly Osgood Childers (left) and Mary Spring Rice (right) aboard Childers's yacht, the *Asgard*, running guns and ammunition to Irish rebels for the looming 1916 Easter Rising in Dublin. *National Library of Ireland, Dublin.*

event in which she and her husband took such a memorable part will never be forgotten by the Irish nation."

De Valera was right in his assessment that the Howth gunrunning feat would remain a revered chapter in Ireland's fight for freedom. The fate of the *Asgard* itself, however, proved less certain. She was refitted and repaired in the early 1960s, and from 1968 to 1974, the Irish navy used the ketch as a training vessel.

In 1974, the *Asgard II* replaced the Childerses' venerable ketch, and the original began a sad, slow descent into near oblivion. She was placed in dry dock at Kilmainham Jail in 1979 and has sat there for nearly twenty years, a proud relic of Ireland's past relegated to a historical afterthought.

De Valera

When "Ireland's Lincoln" Came to Fenway Park

At Fenway Park on June 29, 1919, cheers erupted from forty thousand seats. The spectators roared for a thin, bespectacled man striding toward home plate. They chanted his name, but it was not the name usually bursting from Fenway crowds—star left-handed pitcher and slugger Babe Ruth. The name on everyone's lips was de Valera. The famed Irish rebel had come to plead his homeland's cause to the Irish of Boston. A living symbol of the brutal Easter Rising of 1916, he brought his cause to such Irish American bastions as New York City and raised money to arm and support Michael Collins and the other rebels back home.

In New York on June 26, 1919, de Valera returned to his Waldorf-Astoria Hotel room, paid for by American supporters of Irish leaders, and was handed a telegram at the lobby desk. The letter from Boston Mayor Andrew J. Peters read, "On behalf of the citizens of Boston, I have the privilege of extending to you the greetings of a city whose citizens have such sympathy with the cause for which you are working. It will be a great pleasure to have you with us."

"Dev" had agreed to speak in Boston and local politicians used their clout to reserve Fenway Park for the occasion.

On June 29, 1919, dozens of marching bands filed into Fenway, both the Stars and Stripes and the orange, white and green banner of the fledgling "Irish Republic" nodding above the marchers' heads in the warm air. A horde of Irish men and women clotted the turnstiles and pushed their way to the stands. With room for only thirty-three thousand or so in the seats, thousands of spectators streamed onto the field. The green façade of the

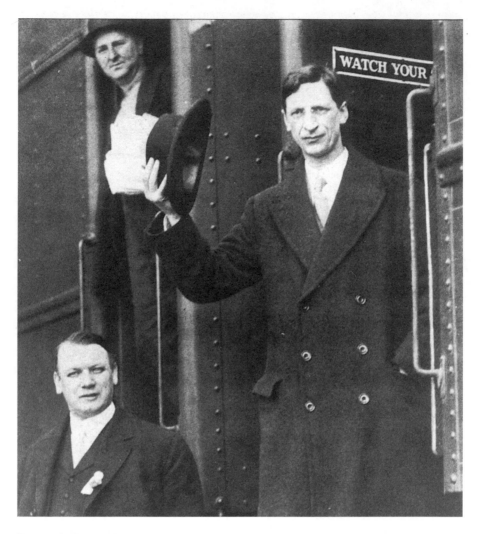

Eamon de Valera (right) arrives at South Station, Boston. *Boston Public Library.*

ballpark, commented a local wag, had never looked as green as when the Boston Irish came to hear Dev.

Suddenly, all eyes turned to a band and a knot of dignitaries flanked by a phalanx of policemen who cleared a narrow path through the crowd. Cheers rumbled from the stands and across the diamond as the throng recognized Dev amid the police and officials. As the group inched toward the podium at home plate, "heads were bared as Old Glory passed and remained so until the Irish tri-color had gone on." The band blared patriotic tunes, both American and Irish.

De Valera (center) greeted by Boston politicians and other notables before his speech at Fenway Park. *Boston Public Library*.

Reverend Philip J. O'Donnell, the rector of St. James's Church, climbed onto the platform and stood behind the podium, which had several megaphones attached. He signaled for quiet, and when he had some semblance of it from the boisterous crowd, he leaned toward the megaphones and, in his finest pulpit tones, offered de Valera "the best wishes and greeting of Cardinal O'Connell," who had been unable to attend. Then, as the throng lowered their heads, O'Donnell offered a prayer for Ireland.

The next order of business was the reading of a letter from Calvin Coolidge, the governor of Massachusetts, who was out of the city to receive medical treatment. "Silent Cal" had written that America must support the concept that all men should be free. With wry understatement, Coolidge had surmised, "Mr. de Valera would find especially strong in Massachusetts the desire for freedom of his land." One look at the Fenway crowd attested to the truth of the governor's words.

Following Coolidge's message, Mayor Peters took the podium, turned to de Valera and expressed "confidence that you will guide to a successful solution the difficult problem of the Irish people."

Then, the moment Boston's Irish had awaited materialized. Dev replaced the mayor at the podium, and a groundswell of cheers shook the field and

the stands. Several times the hero of the Rising, one of the lucky ones, like Collins, to have escaped a British firing squad, raised his hands for quiet. Finally, the din ebbed just enough for him to speak.

His voice did not carry well, and the crowd strained to hear. But his message proved powerful. He blasted the League of Nations for its failure to uphold Ireland's "equality of rights among nations, small no less than great."

Though his glasses and sober suit hinted at the mathematics professor he had once been, de Valera's speech left little doubt as to the rebel he had become. "The man who established your republic sought the aid of France," he said. "I seek the aid of America." Once again an ovation burst across the ballpark.

As he continued his address, the crowd on the field surged closer to the podium and its platform and "carried press tables and all police arrangements with them." The platform trembled "under the crush of the thousands" and "appeared at times in danger of collapse." Several women fainted in the mob.

De Valera went on, "We in Ireland clearly recognize that if the wrong turning be now taken, if violence be reestablished" by the British forces, America must bear much of the blame for failure to oversee a true League of Nations.

A *Boston Globe* reporter at the scene would write that de Valera's voice, "with a bit of a brogue, notwithstanding his birth in the country [the United States] reminded the Boston Irish that they must never turn their hearts and minds from Ireland and allow it to sink back into sullen despair." Another "rousing ovation" cascaded from the stands and the field as he stepped away from the platform.

When Massachusetts' U.S. Senator David Walsh addressed the crowd, he "asked Mr. de Valera to take back to Dublin" the message that the Irish could "depend upon it that Boston and the United States will never place an obstacle in the way of Irish independence."

Walsh whipped up the crowd's emotions to a near frenzy when he shouted that "if England refuses [to free Ireland] and offers the mailed fist, Irish manhood under the leadership of de Valera will fight." De Valera, Walsh cried, is "the Lincoln of Ireland" and "would take the shackles off Irishmen."

In the cradle of their new country's independence, Boston's Irish had heard the gaunt rebel rekindle their native land's struggle for freedom. Few in the throng at Fenway would forget the day Dev came to town—and many would back his cause with their dollars and their hearts.

PART THREE

COPS, ROBBERS, RIOTERS AND ROGUES

Boston's First Irish Cop

Barney McGinniskin

In the late afternoon of November 5, 1851, a burly six-foot, two-inch man burst through the door of the guard room of the Boston City Police. He encountered raised eyebrows from the assembled force.

"Barney McGinniskin," he cried, "from the bogs of Ireland!"

Boston had its first officially appointed Irish cop. Not surprisingly, his presence soon ignited a political, social and cultural furor in the land of "Yankee icicles."

"This person [McGinniskin] woke up one morning and found himself famous," noted the *Boston Pilot*. "He is the first Irishman that ever carried the stick of a policeman anywhere in this country, and meetings, even Faneuil Hall meetings, have been held to protect against the appointment."

The very notion of an Irish policeman enraged Brahmins and Yankee tradesmen alike in Boston of 1851. Of the city's population of nearly 140,000, 53,923 hailed from Ireland, but on Boston's eight-man Board of Aldermen, no Irishmen represented the immigrants, and only one, Edward Hennessey of the West End, served on the forty-eight-man Common Council. Alderman Abel B. Munroe summed up the sentiments of many native-born Americans with his contention that appointing any Irishman to the police force would create "a dangerous precedent" because, in his opinion, "Irishmen commit most of the city's crime and would receive special consideration from any of their own wearing the blue."

Many Irishmen did have their collective eyes on a slot with the police, for the job's salary—$2 a day for the morning and afternoon beat and $1.20 for the night watch—offered nearly twice the wages of the laborers' jobs

that were the only work open to most immigrants. By 1851, City Marshal Francis Tukey, a transplanted Maine mechanic who had battled his way through Harvard Law School (1843) and seethed with political ambition, commanded a police force of forty-four men. His men earned headlines for their quick fists and controversial raids on North End red-light spots dubbed "The Black Sea" and the "Murder District." None of Tukey's men was Irish, and most of the locals wanted to keep it that way.

On June 9, 1851, Tukey sent Mayor John Prescott Bigelow a letter breaking with the "No Irish Need Apply" credo of the boys in blue:

> *My dear Sir—*
> *As you directed, I have made inquiries in regard to Bernard McGinniskin, and find him to be a man 42 years old, and has a family, has been in this country 22 years—has been employed in a grain store, and as a cab-driver, resides in the rear of 275 Ann Street, has the reputation of being a temperate and quiet man.*
> *Respectfully, your obt. Servt.*
> *Tukey, City Marshal*

On the rare occasions when a police officer was dismissed from his cherished sinecure, a horde of rough-and-tumble men applied for the vacancy. McGinniskin was the first local Irishman with the temerity to seek the job, and to buttress his application, he provided Tukey references from a "who's who" of Yankee merchants lauding McGinniskin's credentials for the police force. On September 19, 1851, Mayor Bigelow recommended the Irishman to the aldermen, and all eight voted in his favor.

A few days later, Alderman Abel B. Munroe did an about-face on McGinniskin's application. Claiming that he had not fully understood that the mayor had espoused an Irishman, Munroe switched his position and demanded that a new vote be taken. Mayor Bigelow, in an impassioned plea remarkable for its pitting a Yankee "champion" of an Irishman against entrenched New England prejudices, sardonically harangued the alderman: "What, then, stands in his [McGinniskin's] way to be treated like other respectable applicants? The answer is this. You were born on the wrong side of the ocean…We cannot forget that you were cradled in the bower of the Shamrock. You cannot be trusted."

Mayor Bigelow refused to withdraw McGinniskin's application and proclaimed he would not act as a "consenting party to the spirit of such an answer." When the second tally was taken, only Munroe voted against the Irishman. McGinniskin received orders to report to Tukey for duty immediately.

With one hurdle cleared for McGinniskin, a second materialized in the "dark, handsome" visage of McGinniskin's new boss, City Marshal

Tukey. Miffed that he might be perceived as a mere lackey of the mayor in McGinniskin's appointment, Tukey unleashed a personal campaign to boot the Irishman from the force before he even reported for duty. Tukey, arrayed with anti-Irish Bostonians, decried McGinniskin's appointment at "the expense of an American."

On November 5, 1851, McGinniskin, sporting a tight smile, strode into police headquarters and handed Tukey a letter from the mayor, who had ordered the marshal to place the Irishman on the night force. At Tukey's command, McGinniskin introduced himself to his comrades in blue and headed out into the "mean streets" of the waterfront that night for the first time.

Tukey's vendetta against the city's first Irish cop escalated over the next few weeks as the marshal declared that McGinniskin "is not a fit or suitable person" for a policeman. Tukey claimed that he had launched his own investigation of the immigrant and had uncovered evidence that he was "a noisy, quarrelsome, meddlesome" cab driver and a ruffian who, in 1842, had been "indicted, tried, convicted, and sentenced, for being engaged in a riot on the Lord's Day, in a church." In a public diatribe against McGinniskin, the marshal alleged that when the Irishman had introduced himself to his

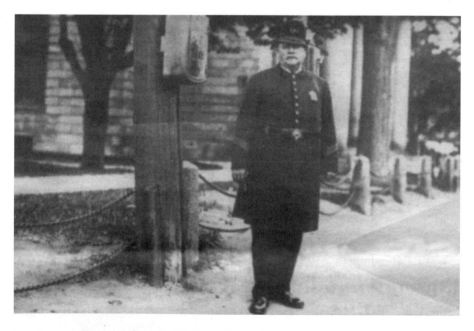

The familiar visage of the typical Boston Irish cop began with an immigrant named Barney McGinniskin, who hailed "from the bogs of Ireland." *Thomas Crane Public Library, Quincy, Massachusetts.*

comrades as hailing "from the bogs of Ireland," he had proven himself a belligerent Irishman looking for a fight.

Of all the vitriol Tukey tossed against McGinniskin, the allegation that the marshal had never recommended him to the mayor goaded a response from the immigrant. He fought back in a public, notarized statement chronicling his interview in June 1851 with Tukey and also released the letter in which the marshal had described him as a peaceable, not a quarrelsome, man. Most tellingly, the Irishman proved that although he had been convicted in the riot, he had actually tried to break up the fracas at St. Mary's Church, in Boston's Irish North End, between a pair of factions brawling over two local priests' disparate views.

The *Pilot* declared the furor over McGinniskin as a clash between the mayor and the marshal. For the moment, Bigelow won out, and McGinniskin remained on the force.

On January 5, 1852, scant hours before the newly elected mayor, auctioneer Benjamin Seaver— whose victory had come partly because of Tukey's support—took office, Tukey fired McGinniskin without giving any reason. The press, though divided in its opinion of the Irish, assailed Tukey as a power-drunk official "getting too big to be contained by Boston." Reporters and editors "do not care a fig...so far as McGinniskin...is concerned," but regarding the papers' and the general public's growing ire at Tukey, Seaver got the message. He reinstated the Irishman.

Barney McGinniskin proved his mettle for nearly three years on the police force, showing as little favoritism toward Irish miscreants as toward Yankee ones. Then, in 1854, a groundswell of anti-Irish rancor espoused by the "Know-Nothing" American Party shook Boston politics and bounced McGinniskin from the police ranks for good. The *Pilot* would record, "Mr. McG was discharged from the Boston Police for no other reason than he was a Catholic and born in Ireland."

McGinniskin remained unbowed by the prejudice. He supported his family by working as a cooper (a barrel maker) and by eventually rising above Yankee bias to become a United States inspector at the custom house. At his home on 29 Clark Street, close to St. Stephen's Church; at police headquarters; and at the custom house, his life proved a fitting tribute to the tenacity of Irish immigrants scrapping for their own piece of the American dream.

McGinniskin, his once muscular physique ravaged by heart problems, died of rheumatism on March 2, 1868. His name was soon forgotten by history. In the decades following his death, however, every time an Irishman donned the blue of Boston's police force, the legacy of Barney McGinniskin—the city's first Irish cop—loomed large.

"Down with Them!"

The Broad Street Riot of 1837

On the sultry afternoon of June 11, 1837, trouble simmered in Boston near and along Broad Street. Fire Engine Company 20 had just returned to its station on East Street, having quelled a blaze in Roxbury. A few firemen had trudged wearily to their homes, but most went to a nearby saloon for a few drinks.

When they headed back toward the firehouse, they waded straight into a crowd of one hundred or so Irishmen on their way to join a funeral procession around the corner on Sea Street. A collision was inevitable. "The Boston firemen, the protagonists in this drama, were then almost entirely drawn from the native [Yankee] stock, and chiefly from those poorer streets of the population among whom hostility to the Catholics and the Irish was fiercest." Several of the firemen moving toward the mourners had reputedly had a hand in the 1834 burning of Charlestown's Ursuline Convent.

The firemen and the Irish met each other on that June afternoon with little more than surly stares, and the engine company had nearly passed through the crowd, which "seemed peaceable enough," without incident. One engineman, however, nineteen-year-old George Fay, "had lingered longer than his comrades over his cups." A cigar dangling from his lips, he either shoved several of the Irishmen or insulted them.

Within seconds Fay and several of the Irish flailed at each other. Fay's comrades rushed to help him, but, "being badly outnumbered, got the worst of it, and two of them were severely beaten" by the Irish. The enginemen fled to their station at the order of Third Foreman W.W. Miller.

Arriving Irish immigrants found a far warmer reception from friends and family than from their new Yankee neighbors. *Ballou's Pictorial Drawing-Room Companion.*

If Miller had merely barred the station's doors, many witnesses would agree, the pursuing Irish would soon have turned back to the funeral. Miller, though, "lost his head completely...carried away either with fear or with rage and thirst for revenge." He issued an emergency alarm so that every fire company in Boston would come to East Street "to take vengeance on the Irish."

The Irish had begun to disperse, but that did not stop the men of Engine Company 20 from rolling their wagon into the street and sounding its bell in a false fire alarm. Then Miller dispatched men to ring the bells of the New South Church and a church on Purchase Street. One of the firefighters dashed to Engine Company Number 8, on Common Street, with a wild message: "The Irish have risen upon us and are going to kill us!"

The Irishmen who had fought with Company 20 were now following the funeral procession, a hearse and several carriages trailed by about five hundred mourners. The cortege wound its way north onto Sea Street, winding toward the Bunker Hill Cemetery in Charlestown.

Engine Company 20, with Miller leading, pursued the Irish. "Let the Paddies go ahead," a fireman shouted, "and then we'll start!"

An onlooker saw the enginemen rush toward Sea Street and the procession with huzzas and cries of "Now look out! Now for it!"

The Irish mourners walked only a block before another band of firemen, Company Number 14, approached. At the sight of the Irish, an engineman cried, "Down with them!"

Nearly at the same moment, the procession turned onto New Broad Street (near today's South Station)—and directly into oncoming Engine Company Number 9. The horse-drawn fire wagon veered into the mourners' ranks, scattering and knocking down men, women and children. The Irish "jumped at the conclusion that Number 9's men had intentionally insulted and assaulted them."

A melee erupted, with Miller, Fay and the rest of Company 20 arriving to join the fray. Fists and kicks flew in all directions, screams of rage and pain pealing along Broad Street. Sticks, cudgels and knives soon materialized, and stones, bricks "and any other missiles that came to hand" slammed against heads and hearse alike.

The Irish and the enginemen would give starkly contrasting accounts of who started the brawl. The Yankee version was that Number 9's engine did not hurt anyone and that the collision was "accidental." As one historian notes, the firemen's version "did not escape charges of whitewashing."

The Irish following the hearse, as well as other witnesses, contended that George Fay, "the very head and leader of the quarrel...seized the rope and guided the engine in among the marchers, while some of the firemen tried to kick Irishmen, and some cried 'Down with them! Trip up the [hearse's] horse!'"

One fact was certain: the brawl soon swelled into a full-scale riot. The hearse's drivers inched their way up Broad Street and eventually reached Charlestown, but the procession was "quite broken up."

Irishwomen and others from the shattered funeral march ran to Broad Street with shrieks for help and fear-embellished claims that the firemen were killing the Irish and that the Yankees had toppled the hearse, smashed open the coffin, pitched the corpse into the street and desecrated it. From all corners of the neighborhoods stretching along the waterfront, Irishmen rushed to the fight. Additional engine companies also poured onto Broad Street, where groaning and unconscious men lay crumpled atop the paving stones.

Crowds of spectators, Irish and Yankee alike, further clotted the street, cheering and exhorting their opposing sides until the brawlers "were excited almost to a point of frenzy."

The weight of numbers lay with the firemen, their ranks buttressed by Protestant workmen, and they drove the Irish all the way down to the entrance of Old Broad Street, a gateway to the Irish neighborhoods. Realizing they were now fighting for their very homes, immigrant men, women and children tore bricks and stones from their own hearths to hurl at their foes.

As the engine companies and their workmen allies scattered Irishmen and surged into the narrow streets, they chased or dragged Irish families from their homes and plunged into an orgy of looting. Historian Edward

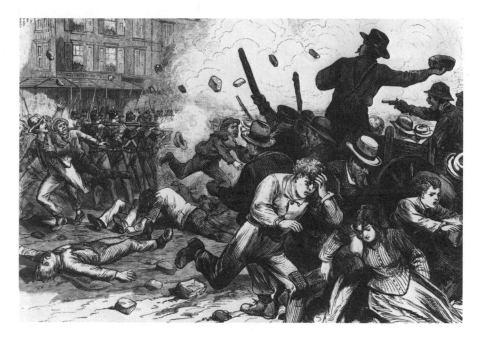

Yankee firemen and Irish workmen battled each other along Broad Street in 1837 until local troops restored order. *Library of Congress.*

Harrington writes,

> *Wherever the marauders broke in, they smashed windows and doors, stole whatever they coveted, and then proceeded with savage thoroughness to destroy everything else. Clothing was torn to shreds, shoes were cut to pieces; furniture and household goods of all kinds were thrown into the streets. Featherbeds were ripped up and their contents scattered to the winds in such quantities that for awhile, Broad Street seemed to be having a snowstorm…the pavement in spots…buried ankle-deep in feathers.*

For immigrants who had been rousted from their cottages in Ireland and had seen their homes tumbled by landlords and British troops, the scene was sickeningly familiar. The looters trashed scores of households.

There is evidence that few firemen, despite their brawling with the Irish that day, actually plundered homes. The blame for the break-ins falls largely upon "stout [Yankee] loafers and young hooligans" who trailed the engine companies, urged them on without joining the fight and "seized the chance" to plunder.

Although continuing the fight, the Irish fell farther back from the overwhelming Yankee gangs. By 6:00 p.m., crowds of terrified immigrants crowded the wharves, their backs literally to the water's edge.

Help came belatedly from a source on which few of the Irish would have counted. Mayor Samuel A. Eliot sent ten companies of infantry and the Boston Lancers, cavalry, on a sweep along Broad Street and the adjacent Irish neighborhoods. The fire companies and their cohorts scattered. After nearly three hours of fury, the Broad Street Riot came to an end.

Although heads had been cracked and blades and clubs had torn men open, miraculously no one had been killed. The number of wounded was so large that it could not be tallied accurately.

In July 1837, fourteen Irishmen and four Protestant men arrested during the brawl stood trial in front of a jury entirely composed of Yankees. Three of the Irish were sentenced to several months in jail. All four Protestants were found "innocent."

Not even the fury of the Broad Street Riot could convince Boston's Irish to abandon their foothold along the waterfront. They had dug in and would refuse to be dislodged in the decades of discrimination to come. On that June 1837 day, they had battled as a community.

The Art of the Double Deal

"Dapper Dan" Coakley and the "Toodles Ryan" Case

Few local historians will dispute that Dan Coakley could have amassed a fortune and a decent reputation had he played his career straight. That was not his way. Angling, scheming, smearing, back-stabbing, double-dealing, talking and buying his way out of trouble—all were the earmarks of one of the most flamboyant, controversial and memorable attorneys and "public servants" Boston ever saw.

At the turn of the twentieth century, Dan Coakley was an attorney and powerbroker on the rise. Ethics, however, did not guide his path—his decidedly crooked path.

With the election of John "Honey Fitz" Fitzgerald as Boston's mayor in 1905, a post—Boston park commissioner—came to Coakley, already a Brighton ward boss and a staunch supporter of Fitzgerald. Although the position was technically an unpaid one, the perks and patronage opportunities it provided added to Coakley's burgeoning fortune.

His law practice had evolved from tort cases to lucrative criminal defenses and whopping civil suits. If it was a red-hot front-page case, one could safely bet that Dan Coakley was somehow involved, and typical of his cases was his defense of Big Bill Kelliher.

The authorities had nailed Kelliher ransacking the assets of the National City Bank of Cambridge. Not even Coakley's verbal pyrotechnics and deft use of tortuous legal angles could save Big Bill from a sentence of eighteen years. Coakley's fee ran in at some $23,000, which his client paid—in "tainted" bills; moreover, from a cell, Kelliher charged that he had paid Coakley to try to bribe the district attorney and the jury. This was no

"Dapper" Dan Coakley, nicknamed "the Knave of Boston" by historian Francis Russell, handled some of the most controversial and crooked cases in and around Boston and beyond for decades. *Boston Public Library*.

problem for Dan Coakley, who mounted a "convincing" self-defense in front of District Attorney Joseph Pelletier of Suffolk County. Of course, Coakley had served as Pelletier's campaign manager—successfully. Pelletier evinced no doubts regarding Coakley's "integrity."

Coakley's close "professional" relationship with Pelletier and Middlesex District Attorney William Corcoran made for a formidable and pliable trio. Of the "triumvirate," historian Francis Russell writes,

> *Those who feared that they might be prosecuted for some previous delinquency found that the district attorneys concerned could be "reasonable" if approached by Coakley. It was soon noised about among the more knowledgeable in Suffolk and Middlesex counties that Pelletier and Corcoran would understandingly* [bury] *cases brought to their attention by that champion of the people Dan Coakley. The understanding, however, was*

expensive. Some of the less sympathetic would even call it bribery. Coakley considered it no more than a matter of oiling the wheels of justice.

If ever Coakley "oiled the wheels of justice," he did so in 1915, when he plunged into the notorious "Toodles" case. Representing the buxom young Elizabeth "Toodles" Ryan in a breach of promise suit against Henry Mansfield, Coakley squeezed every imaginable bit of publicity from the seamy proceedings. He and his client launched a full-bore legal and print assault against Mansfield, the owner of the Ferncroft Inn, a saloon and gambling den on the Newburyport Turnpike. Cards, booze, sex—all could be had at the Ferncroft.

Russell describes Toodles as

> *a blonde, full-bosomed woman in the overblown style of the period...[who] had lived from 1910 to 1914 at the Ferncroft, where Mansfield taught her how to read marked cards, to operate a rigged roulette wheel, and to perform other gamblers' tricks. Her boss paid Toodles seventy-five dollars a week plus her keep. He also gave her presents and took her to Bermuda and Europe, signing her into hotels as his wife. In 1914 she suggested to him that a more substantial financial arrangement would not be amiss. When he demurred, she packed her bags, reportedly shouting at him that "as a grandfather you're fine, but as a man you're rotten. I've got you now on gambling. I've got you on white slavery!"*

Toodles had prominent "friends" who just happened to include John "Honey Fitz" Fitzgerald, and the route from Fitzgerald to Coakley was an easy one for her. In legal and public relations terms, the Toodles case proved tailor-made for Dan Coakley's brand of advocacy. He quickly labeled it as a battle of "Beauty and the Beast," deriding Mansfield as a "card cheat, guller of his friends, liar and piece of gross flesh." In court, Coakley, whose histrionics could cow even the toughest sorts, verbally beat down Mansfield until, the press and later Russell relate, Mansfield was quaking on the stand. The attorney, glowering and pointing at Mansfield, roared, "Oh, the dog! Oh, the dog!"

The press had a field day with the trial, and while the public agreed with Coakley's depiction of Mansfield as a lowlife, not many readers or spectators—especially women—warmed up to Toodles as "victim." The trial resulted in a hung jury, but when Mansfield rushed to make a settlement with Toodles and Coakley rather than subject himself to another round with the bombastic attorney, Coakley had his victory. Toodles, in one final bit of rancor against her former paramour, sneered to reporters, "I wouldn't marry that fat old slob anyway!"

FITZGERALD DENIES HE EVER KISSED "TOODLES"

Supt Pierce Also Disavows Charges Made Regarding Miss Ryan.

Names of Prominent Men Used in Trial of Suit Against Mansfield.

"I NEVER KISSED HER."

"I never kissed 'Toodles,' nor do I remember ever seeing any more than a picture of the Ryan woman," said Ex-Mayor John F. Fitzgerald last evening in an address before John J. Williams Council K. of C. of Brookline, in Fraternity Hall.

Nearly 200 members and friends of the organization gathered to hear him speak on local political events. Mr. Fitzgerald came late and explained that he had detained through having to attend to a denial of the newspaper statements reflecting upon his actions at the Ferncroft Inn.

One of the disagreeable features in public life, and one that keeps many a good man out of it, is the ease with which a man can be attacked, and for which there is no redress. In my 30

Continued on the Sixth Page.

WHERE NAMES COME IN

It was full of thrills, the session of the Ryan-Mansfield breach of promise case in the third session of the Superior Court yesterday afternoon, but it required little effort on the part of the court to restrain the thrills.

> Ex-Mayor Fitzgerald—"It's a lie, pure and simple."
>
> Supt of Police Pierce—"There is not a word of truth in it."

The testimony was more interesting to the crowded courtroom than it has been for the past few days. This fact only made the waiting line outside the more patient, and at the same time more determined to wait for a chance to get in.

Continued on the Sixth Page.

John "Honey Fitz" Fitzgerald was scorched by the press in the case of "cigar girl" "Toodles" Ryan, Fitzgerald's reputed mistress. *Boston Public Library.*

For Dan Coakley, a torrent of controversial cases was to follow the Toodles vs. Mansfield suit—as would Coakley's own legal woes. He would go on to earn further infamy as a "rackets lawyer," and his many enemies and friends alike heaved a collective sigh of relief at his passing in 1953—before he could finish the memoir that he promised would expose all of Boston's "high and mighty's" sins. If anyone knew all the dirt, it was Coakley.

PART FOUR

BLUEPRINTS FOR SUCCESS

A Foamy Fortune

Lawrence J. Logan

The Boston Beer Company. For today's discerning beer lovers, the name means the Sam Adams brews. The fact that a man with the German surname of Koch heads the brewery might surprise few, especially given his roots as a sixth-generation brewer whose ancestors found success in the trade in Cincinnati and St. Louis. What might surprise people is that Koch's Boston Beer Company is the second incarnation of the title. The original Boston Beer Company, chartered in 1828, was a titan in the field for generations until it closed its doors in 1957. It was run in large part by men with monikers from the Emerald Isle.

In the late 1800s and early 1900s, Jamaica Plain and Roxbury were the centers of the local brewing industry because those neighborhoods in the Stony Brook Valley had the open space the sprawling breweries needed as well as the clear, cold water of the Stony Brook Aquifer. A 2005 *Modern Brewing Age* article relates, "Most of the old brewery structures still standing have been turned into warehouses and storage, and they're hard to find tucked away amid a maze of narrow streets once populated mostly by immigrants from countries like Germany and Ireland. The German legacy is easy to see in Jamaica Plain's streets, which bear names such as Beethoven and Bismarck."

Boston historian Michael Reiskind notes that a century ago, Boston "was a beer hub to rival Midwestern brewing capitals such as Milwaukee, St. Louis and Chicago...A city better known for its baked beans and clam chowder had the greatest number of breweries per capita at the time."

Before the German legacy began, though, the Irish had claimed a lucrative foothold in the local beer business. Irish immigrants to Boston

favored robust ales rather than the lagers that the Germans preferred, and in 1828 at D and Second Streets, in South Boston, the Boston Beer Company was founded to slake the thirst of Irish laborers working the docks and construction sites of the city. Eventually, the brewery evolved into a vast five-story complex, the pungent smell of hops and other ingredients wafting across South Boston, the clatter of wagons hauling barrels of beer to local watering holes echoing along D and Second and beyond.

It was only natural that the Irish clawed for a piece of the brewing industry, writes Thomas O'Connor in *The Boston Irish: A Political History*: "The grocery business, for example, proved to be an auspicious starting point for many immigrants during the nineteenth century. The often-attendant liquor industry produced wealthy entrepreneurs such as James Kenney, Michael Doherty, and Lawrence Logan, whom the social historian Dennis Ryan has called 'baron of Boston's liquor business.'"

Lawrence J. Logan, born in Galway in 1842, came to Boston an impoverished immigrant like so many of his countrymen. He worked his way up the corporate ladder of Boston Beer to become president of the company, amassing a fortune along the way. Keeping the books and a wary eye on the bottom line for the concern was Denis H. Tully, "one of the most extensive produce and wine [and beer] merchants in Boston." He had arrived in Boston from Ireland in 1854 as a trained civil engineer and had

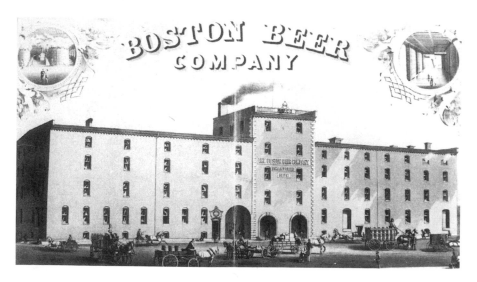

The Boston Beer Company, in South Boston, slaked the thirst of local Irish workers and made a fortune for Galway immigrant Lawrence J. Logan. *Boston Public Library*.

a way with numbers that earned him an entry-level slot "in the counting-room of a large wholesale house." By the 1870s, he was treasurer of the Boston Beer Company, tracking every wagonload rattling across the city's streets, counting every cent made and allocated.

By the turn of the twentieth century, Lawrence Logan was raking it in as head of the company. There were at least eighteen large breweries operating in and around Boston, but the Galway-man's outfit dominated the "Irish market," the pubs in the Irish wards serving up barrel after barrel of "suds" brewed at the corner of D and Second Streets. In the neighborhood stores, Logan's wares were well represented.

When Prohibition was ratified on January 29, 1919, dark days loomed for the Boston Beer Company and fellow brewers. Logan passed away in 1921, and the business that he and other Irish entrepreneurs had shepherded for decades was reduced to turning out the watered-down "near-beers" allowed by the law. Still the company survived, and when the repeal of Prohibition came in 1933, the Boston Beer Company once again brewed the "real stuff."

In 1957, the original Boston Beer Company shut its doors for good. The brewery, which had for almost 130 years given the city enterprising men with names such as Logan and Tully, faded from local memory. Fittingly, the new Boston Beer Company, founded in 1985, now brews the city's signature beer under the same name that brought hearty ales to the Boston Irish from 1828 to 1957.

"The House that Logue Built"

Fenway Park

O n April 20, 1912, some twenty-seven thousand spectators jammed the stands for the Red Sox home opener. This opening day, however, heralded a new era for the club. As starting pitcher Buck O'Brien rocked into his windup and uncoiled the season's first pitch at the New York Highlander's leadoff hitter, he did so in a brand new ballpark. Fenway Park was in business—in large part thanks to an Irish immigrant named Charles Logue. The Derry-born contractor's company had built the ballpark destined to become a shrine to "the Grand Old Game."

In the years before the Charles Logue Building Company's crews first put pick and shovel to the plot of land between Lansdowne and Jersey Streets, its owner and other local Irish contractors had begun to leave a literal brick, steel and granite mark upon the Boston landscape. In *Beyond the Ballot Box*, Dennis Ahern writes, "Irish immigrants learned early that the city streets were not paved with gold, but some, as contractors, found that fortunes could be made by digging them."

A number of Boston Irishmen parlayed practical, hard-won knowledge of construction and unbridled ambition into fortunes. Thomas H. O'Connor, in *The Boston Irish—A Political History*, notes, "With growing need for roads, houses, sewers, and bridges in the new Irish neighborhoods, the contracting business also flourished. Patrick O'Riordan became a millionaire working on city projects…Timothy Hannon helped fill in the Back Bay, and Owen Nawn's trucking company that carried granite from the quarries attracted lucrative contracts from City Hall and the public utility companies."

In the vanguard of Irish-born contractors turning construction into cash was Charles Logue, born in Derry in 1858. A bearded man with a genuine talent for shaping land to architects' plans and the father of a large family, Logue carved a stellar reputation as a man whose company finished jobs on deadline and without questionable cost overruns, something that could not always be said of the city's more than 230 Irish contractors in the early 1900s. Logue's business approach, which earned him financial success from building structures for the Catholic Archdiocese and for Boston College, would serve him well when John Taylor, son of the *Boston Globe*'s publisher, General Charles H. Taylor, who had given his son the ballclub as a "perk," began in earnest in 1910–11 the search for a contractor to build a new park for the Red Sox.

On June 24, 1911, John Taylor issued the news that he intended to build a new ballpark for the Red Sox. Naturally, his father's newspaper trumpeted the news, with a half-page drawing and a detailed accompanying story stoking fans' fervor. The article stated, "With the new park covering 365,306 square feet of land and the stands of the most approved type, and the home club brought up to its best pitch, the fans hereabouts can confidently look forward through the winter months to some great baseball games next season."

Trolley lines ran near the site in the Fenway, which had been a fetid mudflat until it was drained as part of Frederick Law Olmsted's Emerald Necklace plan. It would seem fitting that the park was named for the site itself, but the truth was that the moniker "Fenway Park" paid tribute to the Taylors' land company: Fenway Realty. Many baseball historians have deemed the ballpark's construction as little more than a lucrative real estate deal. Once the first shovels bit into the Fenway, the Taylors sold 50 percent of their interest in the ballclub for a pricey $150,000 to cover their initial outlay. Then, in a slick financial gambit, they held onto outright ownership of the rising new park.

Charles Logue, the Derry-man with a reputation for straight-shooting negotiations, reliability and deadlines met, broke ground at the Fenway on September 25, 1911. A state-of-the-art steel and concrete ballpark—one of the world's first of its kind—began to materialize on a tract whose most distinctive previous buildings had been the Park Riding School and a church. A different type of church, a "baseball cathedral," began to rise, courtesy of the Taylors' bankroll and the skill of Charles Logue and his "pick-and-shovel men," many of them, like their boss, Irish immigrants to Boston.

Logue and his crews had to follow both the architects' plans and the realities of "day baseball." A Fenway Park historian writes, "There was no thought of night baseball in 1911, so the architects had to make sure batters would not be facing into the sun late in the afternoon. Thus home plate was

set in the southwest corner of the yard…to ensure that the sun would set behind third base, bothering only the right fielder." To the eternal agony of countless right fielders who would lose balls in the Fenway sun, Logue followed the plan to the letter.

When Logue and his men laid out left field, they did not build the immortal "Green Monster." That landmark would not rise until 1933, but they did build to specifications that, because the Boston & Albany Railroad wound along the tract's far side, forever meant that Lansdowne Street would lay only a bit more than 300 feet from home plate. The distance from the plate to the fences did not mean as much to the builders of the "dead-ball" era in 1911–12. Few players could drive the ball of the day more than 350 feet, and outfield fences, as Curt Smith writes, were "supposed to eliminate gate-crashing and free looks from the street."

By opening day of 1912, Logue had delivered the goods. Fenway Park was ready, completed at a cost of $650,000 and with private funds only.

John Taylor moved his Boston Red Sox from the Huntington Avenue Grounds, which they leased, to Fenway Park in 1912. The new stadium was built specifically for the Red Sox.

Washed out by rain for two days, Fenway's christening arrived on April 20, 1912, the stands packed with fans gaping at the technological "marvel." The New York Highlanders, who would be renamed the Yankees in 1913, were a fitting opening-day foe, as the raucous rivalry between the clubs for decades to come would prove.

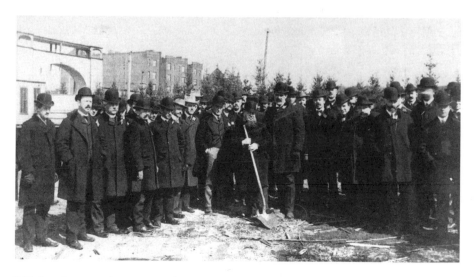

Irish immigrant and contractor Charles Logue (second from left) at the groundbreaking ceremony for Fenway Park. *Boston Public Library; Northeastern University Sports Information Department.*

The New York nine cuffed Red Sox starter Buck O'Brien around for three runs in the top of the first, and the "Fenway Faithful" of twenty-seven thousand, which featured a who's who of local politicians, might have thought a long afternoon was on tap. The Sox then clawed back for a run in their half of the first inning. New York reached O'Brien for two more to go up 5–1, and O'Brien was yanked in the fourth in favor of reliever Charley Hall. The Red Sox bats woke up in the bottom of the fourth, the soon to be familiar roar of the crowd above Fenway pealing from the stands as the surging Sox plated three. By the end of the inning the score stood at 6–6.

In the eleventh, Red Sox second baseman Steve Yerkes, already 5 for 6 in the number 2 slot, got on base again. Tris Speaker stepped to the plate and drove in Yerkes for a dramatic 7–6 victory. Fenway's first game had lasted three hours and twenty minutes.

What should have been the newspapers' big story was eclipsed on the front pages by the most recent developments in "the story of the century"—the *Titanic* had gone down just a few days before the Red Sox unveiled Fenway Park to the fans.

Following their opening day triumph, the 1912 Red Sox went on to rack up their best record ever, 105–47, and beat the New York Giants in the 1912 World Series.

If Yankee Stadium is "the House that Ruth Built," perhaps, in some measure, Fenway Park could bear the title "the House that Logue Built" (or helped to build, anyway).

In 1995, Charles Logue's grandson John I. Logue would write, "It's important to me and my extended family that my grandfather is known as the builder of the ballpark which is so prominent in the history of baseball."

PART FIVE

THE WRITE STUFF

"The Irish Belle of Boston Letters"
Louise Imogen Guiney

Louise Imogen Guiney grew up in a hero's household. The only child of Patrick R. Guiney and Janet Margaret (Boyle) Guiney, Louise was born in Boston on January 7, 1861. Guiney's father was a lawyer on the rise, a County Tipperary immigrant who had worked as a machinist in Lawrence, Massachusetts, and had spent nights studying for the bar. Once settled in Boston, he plunged into politics and dreamed of a day when rebellion would break out in Ireland. Just a few months after Louise's birth, he enlisted in the Irish Ninth Massachusetts Infantry, in whose ranks he planned to learn the martial lessons that he believed were necessary to Ireland's cause.

By the Civil War's end in April 1865, Louise knew little more of her father than that he was a hero, a veteran of thirty-six battles and a man who had earned a brevet brigadier general's epaulets. When he returned to Boston for good, he was a man venerated by fellow Irish immigrants and a man whose health was shattered by a head wound.

His slow physical deterioration notwithstanding, he returned to the law and, for the first time, truly became acquainted with his little girl. Louise was in awe of her father. His refusal to let anyone push him around and his unwavering devotion to his birthplace and his religion were cornerstones of her upbringing. But his greatest gift to Louise was a love of learning, especially literature. Once he discovered that his only child shared his innate passion for books, the bond between father and daughter deepened. They read and discussed history, philosophy, religion and, above all, novels and poetry.

Though not a beauty, Louise Guiney grew into a teenager whose intelligence and determination set her apart from many of her era's young

Irishwomen whose fathers had found success and whose chief desire was to make a good match with a similarly placed Boston Irish young man. Before any of that happened for Louise Guiney, however, her father, who wanted her to receive a good education, sent her to Elmhurst, the Order of the Sacred Heart's convent school in Providence, Rhode Island. Neither she nor her father welcomed the separation from each other.

On a chill, blustery March day in 1877, Patrick Guiney collapsed and died in the street outside his house. For his widow and his disconsolate daughter, years of "privation and disappointment loomed."

Eighteen-year-old Louise Guiney graduated from Elmhurst two years after her father's death. She returned to a household empty not only of her beloved father, but also bereft of cash. For Louise, the logical course would have been to find a husband to support her and her mother. But this young woman had a different plan. It was chancy, yet one unwittingly shaped by her father's having stoked her love of literature. "The memory of him had molded her character" and prodded her toward a vocation he had craved, but had been unable to pursue. Louise Guiney believed that she could earn a living as a writer and poetess.

Having left Louise "an imperishable image of a brave and noble soul," Patrick Guiney had also imbued her with a necessary dose of pragmatism. She understood that to augment a small veteran's widow pension and the scanty savings that she and her mother lived on, the aspiring writer could not just craft poetry, but had to turn out more prosaic material for pay. Louise wrote articles for "ladies magazines" and newspapers—"hack writing," as highbrow literary lights of the day termed such plebeian work. She also became a paid researcher for other writers and local scholars.

All the while that Louise wrote pieces for others, she somehow found time to hone her own voice in plaintive poems and personal essays. Swallowing fears of rejection, she submitted a slender collection of her verse to a Boston publisher in 1884. An editor saw Louise's collection, *Songs at the Start*, as emotional, fluidly composed poetry that would appeal to women.

Sales of Guiney's first book proved modest, but her style caught the collective attention of Boston's literary community and earned her friends among Brahmin writers whose chief exposure to the local Irish had been the help hired from the city's wards. She solidified her growing status among intellectuals with an 1885 collection of essays in the prestigious literary magazine *Goose Quill Papers*.

With her essays and verse bringing in just enough money to allow her to develop her talent further, Louise immersed herself in classic poetry that evoked wistful memories of the love of words she had shared with her father. As she shaped her new poems and prose, she found and welcomed "his poetic aspirations flowering in her lyrics."

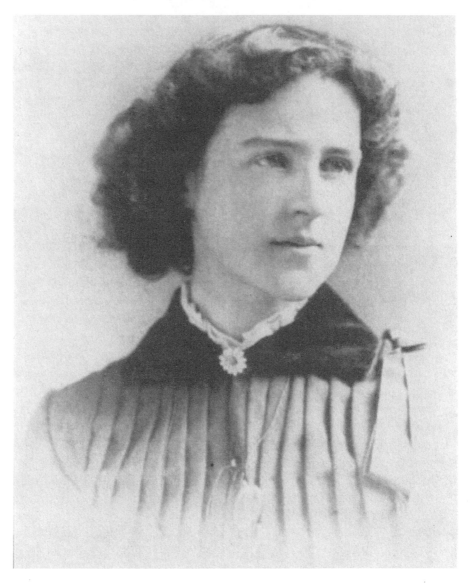

Louise Imogen Guiney. *Library of Congress.*

Having always envisioned her father as "a brave and noble soul," Louise Guiney was drawn to the poetry and plays of seventeenth-century England, the era of cavaliers who spouted verse and handled a saber with equal aplomb. As later scholars of American literature would point out, she saw her father in those heroic figures and found a way to feel close to him through the printed word. An unabashed Irish nationalist, he might have preferred that his daughter liken him to warrior princes or bards of ancient

Ireland, but surely would have been flattered at how she translated "his valor…into a spiritual heroism" in her writing and in her own life.

Despite her burgeoning reputation and her literary band of friends and supporters, Louise's personal life never bloomed in the same way as her work. Though cheerful and popular, she invariably measured potential suitors against her father—and invariably found them lacking in comparison. Even if some young man possessed those qualities of the cavalier she sought, Louise Guiney was ill-equipped through no fault of her own for the usual small talk of flirting and courting: "deafness, which had begun in her young womanhood, grew steadily oppressive."

Louise, in 1894, garnered a rare achievement when she was appointed postmistress of Auburndale and became the first Boston Irish woman to hold such a position. She later took a job at the Boston Public Library, where she helped children looking to improve their lives through learning.

Her jobs did not deter her from her poetry. In 1887, she published *The White Sail*, one of her most popular volumes of poetry, earning her the sobriquet "the Irish Belle of Boston Letters." She also began to stretch her writing into the spheres of literary criticism and biography. Although she had never attended college, she proved herself a first-rate scholar and "became ultimately as learned as anyone of her generation." In 1894, she wrote *A Little English Gallery*, in which she scrutinized the work of great British writers. Her book was praised as "precise in scholarship and opulent in sympathy."

In 1901, after two trips to Great Britain, Louise Guiney left her beloved Boston to live and work in Oxford, where she wanted to expand her scholarly and poetic skills at the university's matchless libraries. She sent a steady stream of breezy letters to her Boston friends, rarely relating the facts of her nearly total deafness now and her "practice of stinting herself of food and coals in order to buy precious books." Her health suffered from privation, but her love of "grubbing for facts" and of writing drove her to ignore her waning health as she delved into a project that her fiercely Irish Catholic father would have loved: an anthology of the world's greatest Catholic poets.

Louise Guiney never finished the book. On November 2, 1920, she died at the age of fifty-nine, worn out from her literary labors.

In the following decades, various scholars dismissed her poetry as derivative and ordinary. But they could not dismiss her verse's popularity. Her poems, which she had constantly revised until the days just before her death, would appear in numerous anthologies.

More important perhaps than any comparisons to Emily Dickinson and other renowned American poetesses, Louise Guiney stands virtually

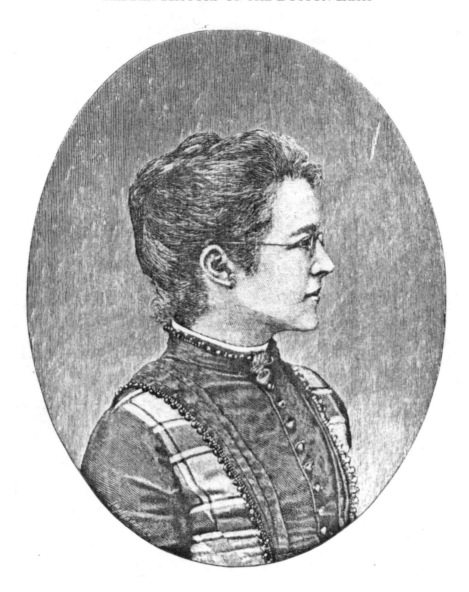

Poetess Louise Imogen Guiney in later life. *James B. Cullen,* The Story of the Irish in Boston.

unchallenged as a cultural and social icon. She was the first Boston Irish woman to make her mark in American literature. From the immigrant neighborhoods of Boston, she carved out an improbable career for most nineteenth-century women. She had shown that the Guineys of Boston were as remarkable with words as in war.

"On This Rock"

John Boyle O'Reilly's Paean to Plymouth Rock

When it comes to Thanksgiving, images of the Pilgrims and Wampanoag Indians gathered at long wooden tables piled with platters of food are the norm. Every November, American families gather as those tenacious English colonists did in 1621, and Thanksgiving traditions do not normally reflect anything Irish. Yet, in 1889, at the ceremonies dedicating the national monument at Plymouth Rock, the broad-shouldered, mustachioed poet who rose to deliver the main speech was not someone bearing the name Bradford, Alden, Winslow or Carver. The writer was not a celebrated Yankee author such as Oliver Wendell Holmes. The man who delivered the ode to the Pilgrims was an Irishman—and not just any Boston Irishman.

John Boyle O'Reilly had been a Fenian, once condemned to death by a British military court. Only his daring escape from a prison in western Australia had brought him to the same shore where he now prepared to honor a vivid national symbol: Plymouth Rock.

O'Reilly—the nationally acclaimed editor of the *Boston Pilot*, essayist, novelist, athlete, ex–British army soldier, Fenian organizer and rebel— had carved out an astonishing literary career in Boston. In the words of an admirer, O'Reilly "was born with the gift," the gift of the poet.

O'Reilly was born near Drogheda, County Meath, on June 28, 1844. By the time he reached the United States in late 1869, he had been a writer, a soldier, a Fenian prisoner and a man whose life could have served as grist for the skills of Melville.

Living in Boston in an era when Irish writers often received the proverbial cold shoulder from America's literary lions, O'Reilly won their acclaim with

John Boyle O'Reilly as he looked at the time he wrote his ode that commemorated the unveiling of Plymouth Rock in 1889. *Burns Library, Boston College.*

his sheer talent as a wordsmith and was selected in 1889 to compose and deliver an address and ode to "the Pilgrim Fathers" at the unveiling of the Plymouth Rock monument. The erstwhile Fenian firebrand had not only elbowed his way into the American world of letters, but had also beaten out a long list of local Yankee writers.

The dedication of the Pilgrim Monument garnered nationwide coverage by the press, and O'Reilly was under some pressure to deliver a poem worthy of both his talent and of the occasion. The *New York Times* trumpeted the meaning of the day as a symbol of how far America had come and how

much it had been shaped by the values and aspirations of the Plymouth colonists. The *Times*'s front-page story on August 2, 1889, related,

> *The joyful clanging of iron bells, the sounding boom of heavy cannon, and the ringing cheers of a city's inhabitants greeted the sun as he rose this morning, ushering in the greatest day this historic old town* [Plymouth] *has ever known...The whole town had been up for hours, and had it rained buckets full, this great celebration—the dedication of the splendid monument in honor of the Pilgrim Fathers who made Plymouth Rock historic 269 years ago—would have been carried through to a close with as much loyal enthusiasm as if the celebrants had been blessed with the fairest day that the sun had ever smiled upon.*

The crowd of dignitaries and citizens from all over the nation gathered early for the ceremonies, scheduled to commence at 9:30 a.m. on August 1, 1889. "Battery A of Boston kept its guns hard at work even after the bells had grown quiet," a reporter noted. "The cheers of the multitude outlasted both."

As O'Reilly had labored over his ode, he had seized upon a theme familiar to all the Irish who had left their "ould sod" for the promise of the New World: he drew subtle comparisons to the journey of William Bradford, Myles Standish and company. Now, on that cloudy morning, the ex-Fenian stood at the monument among a veritable "who's who" of Yankee scions— men with such names as Lodge, Endicott, Long and Mather. The Irishmen saw that "every inch of space for hundreds of feet about the pedestal was occupied."

"Visitors had been pouring into town all of yesterday and on the early trains this morning," an observer wrote, "and probably Plymouth never held such a crowd before. Everyone attended these dedicatory services, and there was hardly space enough about the monument to provide all with even standing room."

After several testimonials to the Pilgrims and the monument were delivered, John Boyle O'Reilly stepped forward. In a reception that proved yet again how far the Irish-born writer had climbed in the collective opinion of his fellow immigrants and native-born Americans alike, a newspaperman recorded that "the introduction of John Boyle O'Reilly elicited much enthusiasm."

"Mr. O'Reilly was the poet of the day," the reporter added.

Papers in hand, the Irishman cleared his throat and began to read aloud his ode, "The Pilgrim Fathers." The crowd was riveted by the poet's words, each stanza a moving and memorable paean not only to the long-departed

John Boyle O'Reilly writing in his study. *Burns Library, Boston College.*

Pilgrim men, women and children who had established their foothold in the wilderness in 1620, but also to the very idea of America itself as a haven and a fresh start for the dispossessed of the Old World. One of the poem's most telling stanzas ran in newspapers nationwide:

> *Here, on this rock and on this sterile soil,*
> *Began the kingdom not of Kings, but men;*
> *Began the making of the world again.*
> *Here centuries sank, and from the hither brink*
> *A new world reached and raised an old-world link,*
> *When English hands, by wider vision taught*
> *Threw down the feudal bars the Normans brought,*
> *And here revived, in spite of sword and stake,*
> *Their ancient freedom of the Wapentake.*
> *Here struck the seed—the Pilgrims' roofless town,*
> *Where equal rights and equal bonds were set,*
> *Where all the people equal-franchised met;*
> *Where doom was writ of privilege and Crown;*
> *Where human breath blew all the idols down;*
> *Where crests were naught, where vulture flags were furled,*
> *And common men began to own the world.*

Such lines as "the feudal bands the Norman brought" and "vulture flags" certainly elicited references to the Normans who invaded Ireland from England long ago, in the 1170s, and began the long and brutal subjugation of the Irish. O'Reilly's verbal shots at "privilege and Crown" were redolent of a former Fenian who had been denied freedom in his own land, only to find it in that of the "Pilgrim Fathers."

John Boyle O'Reilly recognized that, in Boston and New England, the Irish were still clawing for their own foothold in America. His words in Plymouth brimmed with the hope that for the Irish, "all the idols" of "Crown" and Anglo-American "privilege" would fall.

As families with Irish bloodlines gather each year to celebrate Thanksgiving, a holiday of such pronounced English roots, it would be fitting to recall the County Meath expatriate who was selected over a Yankee pantheon of writers and poets to dedicate the Pilgrim Monument. Fenian and poet John Boyle O'Reilly claimed a place, so to speak, at the Pilgrims' historical table.

PART SIX

A HIGHER CALLING

"The Boston Irish Florence Nightingale"

Sister Mary Anthony

As a girl, Mary Murphy O'Connell fled famine-ravaged Limerick for Brahmin Boston. As Sister Anthony, she helped revolutionize battlefield medicine during America's most traumatic years. Today, "her innovative triage techniques remain standard practices in every theater of war where American troops fight." Those words come from a 2003 Pentagon report. They laud the woman who revolutionized medicine over 140 years before that report.

Her kind, consoling features proved the final earthly sight of many Yankees and Rebels crumpled across the Shiloh Battlefield. The middle-aged woman clad in the habit of the Sisters of Charity covered virtually every inch of the bloody turf, from the Hornet's Nest to the banks of the Tennessee River, comforting the wounded, praying over the dead and dying and directing stretcher bearers' evacuation of the wounded to Union ships.

Sister Anthony, Mary (Murphy) O'Connell, had come a long way from her native Limerick and from the Ursuline Female Academy of Boston. Poverty, the arduous passage across the Atlantic and the prejudice of Boston Brahmins and Yankee workmen had not crushed Mary O'Connell's spirit. They had forged it into the character of the nun about to be dubbed "the Irish Florence Nightingale."

Mary O'Connell was born in County Limerick on August 15, 1814, the daughter of William and Catherine (Murphy) O'Connell. Tragedy arrived early in Mary's life with the death of her mother when the girl was twelve. In 1817, the "forgotten famine," a harbinger of the Great Famine of the 1840s, engulfed Ireland and sent rising numbers of the Irish to America.

Among the "ragged refuse" who trudged aboard leaky, ancient merchant ships were the O'Connells.

The exact date of the O'Connells' immigration to Boston is unknown, but the fact that Mary received her education at Charlestown's prestigious Ursuline Academy, where the nuns taught girls age six to eighteen years, indicates that the family set foot among "the icicles of Yankee land" sometime in the 1820s. Immigrant Irish families of the day lived mainly in the city's North End, numbering about seven thousand by 1830 and beleaguered by Yankee mobs who periodically vandalized Irish neighborhoods on Broad, Pond, Merrimac and Ann Streets.

Many Irish girls of Mary O'Connell's age worked as maids in Boston's hotels and brownstones, in many cases enduring the harsh epithets and whims of Brahmin families or in other, rarer instances becoming valued members of households. Mary was luckier in many respects than her peers, for she was accepted as a student at the Ursuline school, where she boarded with forty or so other girls. Only a handful, however, were Irish Catholics. Most of the young ladies were Protestants, boasting such Yankee pedigrees as Parkman, Endicott and Adams. Because of the outstanding education offered by the Ursulines, a handful of Brahmin families laid aside anti-Papist prejudice and packed off their pampered daughters to the graceful, three-story brick academy and the ministrations of the nuns.

In August 1834, when a mob of Yankee workmen far less tolerant than various Adamses and other Protestant nabobs ransacked and torched the convent in a spasm of anti-Catholic rage, Mary O'Connell was twenty and had already graduated. The influence of her Ursuline mentors had ignited a vocation in her, but unlike her teachers, she did not yearn to educate daughters of privilege. She wanted to minister to the poor and the sick, and in June 1835 she was accepted into the convent of the American Sisters of Charity at Emmitsburg, Maryland.

Leaving behind the familiar streets of the Irish North End, she could never shake images of the charred remnants of the Ursuline convent, testimony to the cultural and social obstacles confronting all Irish Catholic immigrants and particularly their clerics and nuns. Mary O'Connell embraced both her challenges and her faith. She took her final vows in early 1837 and, in March of that year, was assigned to Cincinnati's St. Peter's Orphanage.

As Sister Mary Anthony, she worked tirelessly with the city's victimized Catholic children, combining kindness with an intellect both keen and pragmatic, and rose steadily in her order's hierarchy. By 1852, she was appointed procuratrix of Cincinnati's St. John's Hotel for Invalids. Nursing the sick had evolved into her true mission, and her medical skills would soon prove critical in a catastrophe about to engulf the entire nation. On

April 12, 1861, the roar of Confederate cannon pounding Fort Sumter in Charleston, South Carolina, heralded the foremost challenge of Sister Anthony's career.

Shortly after war was declared, Sister Anthony and several of her fellow nuns began to tend to Union troops ravaged by a measles outbreak at Camp Dennison, near Cincinnati. Her compassion and her knowledge of the latest nursing techniques earned her the plaudits of the camp's officers and the attention of the Union's chief medical body, the U.S. Sanitary Commission. Along with Clara Barton and Dorothea Dix, Sister Anthony was about to reform traditional, often harmful methods of treating wounded soldiers.

The first flash of the Irishwoman's evolving impact upon military medicine materialized during General Ulysses S. Grant's victorious assault upon Fort Donelson in early 1862. For surgical staffs, the campaign, fought along Kentucky's Cumberland River, posed a formidable problem in the transport of wounded soldiers from battlefields to "floating hospital ships." From the gunwales of Union riverboats and on the battlefield, Sister Anthony devised techniques in which medical teams and stretcher bearers sent the most severely wounded to the ships first, dispensing with the traditional practice of carting off the injured at random. Her methods, the first recognizably modern triage techniques in war zones, saved countless lives through faster hospital treatment and won her praise from President Abraham Lincoln. In tandem with her innovations in transport and treatment, she formulated fast and effective nursing programs for female hospital volunteers.

In early April 1862, the Irish American nun boarded a hospital ship chartered by the Sanitary Commission and packed with other nurses and physicians, including George Curtis Blackman, one of America's foremost surgeons. He had personally selected Sister Anthony as his chief assistant. Their destination was a Tennessee River site called Shiloh, where one of the bloodiest battles in America's annals was raging.

Nearly twenty-three thousand Union and Rebel soldiers littered the muddy battlefield by April 17, 1862, their moans and shrieks pealing above the riverbank. Sister Anthony moved swiftly through the carnage and oversaw the transport of casualties to the waiting ships. As always, she made no distinction between Union or Confederate soldiers; she saw only the extent of the wound. Once she returned to the "floating hospital," she took her place as Dr. Blackman's "right arm" at the surgical table, mixing her practical skills with moral support for men torn apart by musket balls, grape shot and bayonets.

At Shiloh, Sister Anthony not only proved a proverbial angel of the battlefield, but also cemented her burgeoning status as a luminary in wartime medicine. She used her clout to compel the Catholic Church to train rising numbers of nuns as nurses, winning the admiration of even anti-Catholic Americans.

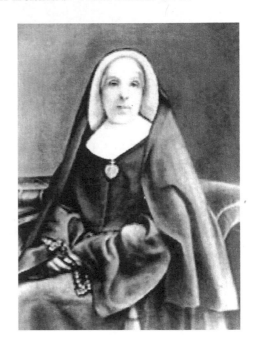

Sister Mary Anthony O'Connell, "the
Boston Irish Florence Nightingale."
Smithsonian Institution.

The Catholic Church officially assigned Sister Anthony to the U.S. Army
of the Cumberland on September 1, 1862, at the request of the Sanitary
Commission. She ran the nursing teams at Base Hospital 14 at Nashville
and comforted not only battered troops, but also runaway slaves suffering
from smallpox, her latter ministrations composing a stellar moment in the
troubled relationship between the era's Irish immigrants and blacks. Sister
Anthony's feats on the battlefield and in the floating hospitals and the
surgical tents alike led the government to commemorate her service and
that of her fellow Sisters of Charity.

After the war's end, the Irish-born nun continued her life of good works.
She died of natural causes in Cincinnati at the age of eighty-seven. Her
funeral, in December 1897, filled the city's cathedral with both Catholics
and Protestants, and outside, another throng gathered to honor the gentle
Sister of Charity. Whenever asked where she had come from, she had
invariably replied, "Ireland—by way of Boston."

Although the names of Barton and Dix would eclipse that of Sister
Anthony, the Irish immigrant, in a career of quiet brilliance, had proven her
mettle second to none. In famine-wracked Limerick, in the anti-Irish streets
of Boston, in the classrooms of Charlestown's ill-fated Ursuline Convent
and on the battlefields of the Civil War, Mary O'Connell's transformation
from an impoverished immigrant girl to the "Irish Florence Nightingale"
had unfolded with dignity, compassion and sheer selflessness.

"It Must Be True Since Mr. Keely Says It Is"

Patrick Keely

Boston's splendid Cathedral of the Holy Cross testifies to his skills and vision. When it came to church design of the nineteenth-century's latter decades, Patrick Keely shaped the landscape. His churches still grace Boston and beyond. Whenever local Catholics attend Mass at the Cathedral of the Holy Cross, St. Peter's in Dorchester and many other ecumenical edifices from Boston to Newport, Manchester, Portland and scores of points in between, worshipers can ponder the literal products of Keely's genius.

The University of Notre Dame bestowed its second annual Laetare Medal, in 1884, to Keely for "changing the style of ecclesiastical structures and modified architectural taste in this country." The award was well deserved, for the Irish-born and -raised immigrant was in the prime of his career as a master builder of churches. They would stand the test of time even as his name faded into relative obscurity.

Patrick Keely was born in County Tipperary, and while his early years remain murky, historians speculate that his family was fairly well off. In the Tipperary town of Thurles, the Keelys lived in a home "that had been occupied as a convent by the Presentation sisters and which had been built by a wealthy distiller named McCormick. Apparently young Patrick received the education available to boys that were expected to be tradesman and mechanics."

It is known that Patrick Keely came to America in 1842 and initially made his way as a carpenter. In an era when master builders devised their own construction plans, the lines between architects and gifted tradesmen could become blurred, and tradesmen without formal academic training

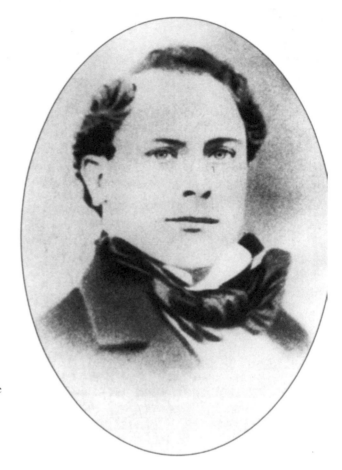

Tipperary-born architect Patrick Keely, who designed many of Boston's most impressive Catholic churches, including the second Cathedral of the Holy Cross. *New York Public Library*.

nonetheless designed and built structures. Still, the formal practice of architecture was taking shape in America as young Keely started his career.

Keely's presence in Boston likely began in earnest in 1851, when he tackled the renovations, rebuilding and enlargement of the Church of Saints Peter and Paul in South Boston. The granite Gothic Revival church had been designed by Gridley J.F. Bryant in 1843 and completed in 1845, but had been heavily damaged in a fire in 1848. Keely was hired to restore and expand the structure and completed his work in 1853.

The impressive results of his renovations on the South Boston church led to numerous commissions from the Boston Archdiocese, and Keely oversaw the construction of his houses of worship from blueprints to spires. The following are all local churches that sprang from Keely's vision into visual reality:

St. James on Albany Street, 1853–55 (Keely's first complete project in Boston from design to construction)
Most Holy Redeemer in East Boston, 1854–57
Notre Dame Academy in Roxbury, 1855–71
St. Francis de Sales in Charlestown, 1859–62
Cathedral of the Holy Cross in the South End, 1861–75
Church of the Immaculate Conception in the South End, 1866–71
St. Francis de Sales in Roxbury, 1867–69
Our Lady of the Assumption in East Boston, 1869–73
St. Thomas Aquinas in Jamaica Plain, 1869–73
St. Augustine in South Boston, 1870–74
Holy Trinity in the South End, 1871–77
St. Vincent de Paul in South Boston, 1872–74
St. James the Greater in Chinatown, 1873–75
St. Peter's in Dorchester, 1873–84
St. Mary's in the North End, 1875–77
Our Lady of Victory, 1877
St. Joseph's Church interior in Roxbury, 1883
St. Peter's rectory, Dorchester, circa 1885
St. Mary's in Charlestown, 1887–92

After Keely's death, in 1896, his sons and son-in-law continued the firm of Keely and Houghton, their projects including St. Margaret's Church in Dorchester (1899–1904) and St. Mary's School in Charlestown (1901–02). Patrick Keely's churches and cathedrals graced not only Boston, but also cities and towns as far as New York, Charleston, Chicago, Milwaukee and many other sites.

While the hundreds of churches Keely designed testified to his skills, his cathedrals—his churches on a grander scale—cemented his reputation as one of the greatest neo-Gothic architects of the era. In fact, some of his churches were built on such a scale that they were nearly cathedrals themselves. After Keely's death, an architect noted:

> *The largely Irish congregations who in their native country were forced to attend Mass on an open hillside, a rock serving as an altar, and with men on guard to watch for the coming of soldiers were quite content with a space for the altar and a roof over their heads.*
>
> *Keeley* [sic] *was able and gave them more but he kept to a fairly simple plan, usually a nave and two flanking aisles. A commendable feature in his plans was the manner in which the minor altars are recessed in small*

chapels so that on entering the church the high altar becomes, as it should, the center of interest.

The great size of these early churches is impressive. They were of such great dimensions that one could easily mistake some of Keeley's [sic] parish churches to be Cathedrals. St. Mary's in Lawrence, Mass. is one of these where the seating capacity is over two thousand and which were needed to care for the great numbers at a time when priests were few and it was not possible to have the number of Masses as numerous as we now find them.

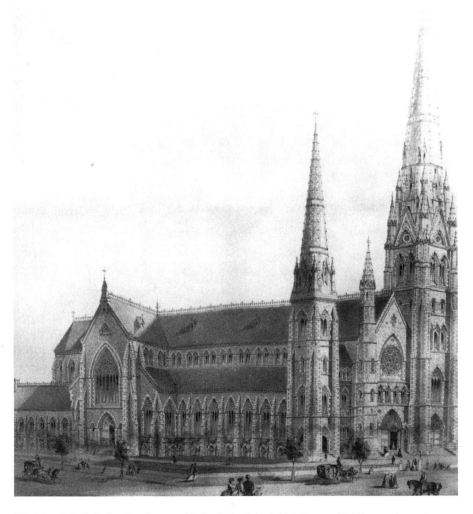

Keely's original design for the new Cathedral of the Holy Cross called for soaring spires that were not built because of the costs. *Archdiocese of Boston Archives.*

Along with the Cathedral of the Holy Cross in Boston, Keely's design skills were also given full rein with expansive budgets in Providence and Hartford. A contemporary article described both works:

> *St. Joseph's in Hartford follows the general design of Providence. It is 268 feet long, 178 feet wide at the transepts and the nave has a width of 93 feet. This latter dimension, of course, includes the full width of the building. The towers are 150 feet high but with the spires, never built, there would have been an added hundred feet. The church is of Portland Stone of a dark brown color and the interior shows the use of Tennessee Marble for the wainscot and the twenty eight great pillars that support the roof. The high altar which Keeley [sic] designed cost $12,000—a huge sum for that time.*

A number of Keely's admirers have singled out his Springfield cathedral, Saint Michael's, as one of his simplest but must noteworthy, its lines in total symmetry with the expansive lawns and stands of trees that flanked it, "creating the atmosphere associated with many old world cathedrals."

In Boston and beyond, Patrick Keely's reputation for getting his designs right and rendering them with the highest professionalism and integrity led to an admiring adage among tradesmen: "It must be true since Mr. Keely says it is."

It is certainly true that a stroll in and around the Cathedral of the Holy Cross, St. Peter's and myriad other local churches speaks volumes about Patrick Keely's impact upon the Boston Irish.

PART SEVEN

SHAMROCK AND SWORD

The Forgotten Irish Heroes of Bunker Hill

The rattle of drums pealed through the sultry air of June 17, 1775. As the sun glinted off bayonets, the Redcoats formed columns and tramped over heaps of fallen comrades for a third time up the slope of Breed's Hill.

Behind a rail fence, a redoubt and a breastwork, the Rebels waited, pouring their last powder and ramrodding their last musket balls down their muzzles. Many colonists lay sprawled amid the defenses, homespun shirts stained with blood, screams and groans echoing across the slope. On the grass in front of the fortifications lay many more British Regulars, hundreds of them, a carpet of red coats and white cross-belts.

Historians would assert that the colonial farmers, tradesmen, lawyers and physicians taking on the vaunted British army were "wholly English." These scholars would neglect to mention that men named Callaghan, Casey, Collins, Connelly, Dillon, Donohue, Doyle, Flynn, Kincaid, McGrath, Nugent, Shannon and Sullivan fired "at the whites of their [British] eyes" at the Battle of Bunker Hill (actually Breed's Hill).

Although generations of American writers would cling to their myth that only Patriots "of pure English blood, with a small fraction of Huguenots and a slight mingling…of Scotch Irish" taught the British army a harsh lesson at Charlestown in June 1775, in truth Irish volunteers helped to man the defenses there. "The sons of the Green Isle" shed their blood on that slope for the dream of American independence.

On Breed's Hill, at least twenty-two native-born Irishmen died for the Rebel cause. Irish American historian Michael J. O'Brien was the man who

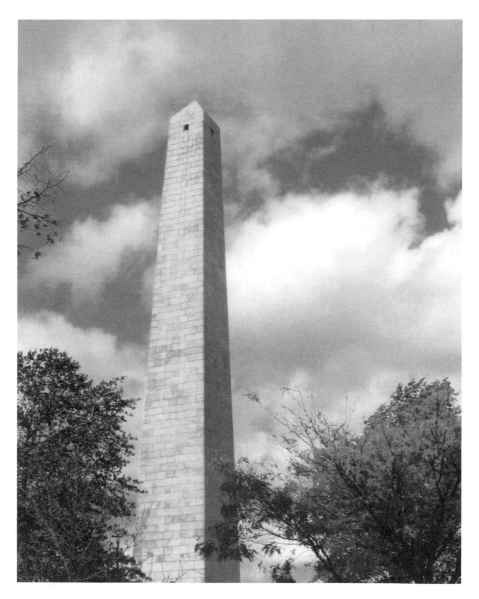

The Bunker Hill Monument, where a plaque testifies to the presence and sacrifice of Irishmen who stood and fought with the Patriots at the Battle of Bunker (actually nearby Breed's) Hill in June 1775. *Photo by Peter F. Stevens.*

first punctured the myth that no Irishmen stood shoulder to shoulder with the Rebels. Through painstaking research, he discovered that forty-one companies of Patriots at Breed's Hill counted Irish casualties in their ranks.

O'Brien next targeted the "Scotch Irish" appellation used by some scholars to obscure the role of the Irish in the American Revolution. By

defining Rebels with "questionable" surnames as "descendants of the Scotch and English" who had emigrated from the northern counties of Ireland, eminent Anglo-American writers masked the true lineage of any men whose bloodlines were Irish, pure and simple.

As O'Brien reveals, many men who fell at the Battle of Breed's Hill were Irish born. Unlike his predecessors, he credited both the Irish and Scottish Patriots as separate entities and harangued scholars for "drawing an Iron Curtain around the Irish, who...brought to America burning memories of the treatment their people had received at the hands of the English, and so were glad of the opportunity to take part in the fight." And fight they did.

On June 17, 1775, some 2,500 British Regulars piled into longboats and were rowed to Morton's Hill as warships and batteries atop Copp's Hill bombarded the Rebels who were dug in on Breed's Hill. The British had already set Charlestown ablaze, and from the colonists' bastions, Daniel Callaghan, Thomas Doyle and scores of fellow Irishmen peered at a frightening sight. Down Morton's Hill streamed masses of Redcoats, regimental colors hoisted above hundreds of tri-cornered caps and grenadiers' shakos (high, gilded hats). The British drums boomed ever louder as the scarlet ranks formed assault columns in a meadow fronting Breed's Hill.

In the ranks of the Irish-born defenders were a number of deserters from British regiments. In Ireland, "press gangs" had kidnapped many young men, hauled them bound and gagged aboard troop transports and informed them that they had "enlisted" in King George III's service. Once in Boston, scores of Irish soldiers deserted at the first opportunity and eagerly joined the Rebel militia to strike back at their British oppressors. Because British officers posted rewards for Irish deserters "now with the Rebels," many of the refugees changed their names. At least seven Irish deserters—Andrew Browne, John Carroll, John Dillon, Thomas Doyle, Thomas Kincaid, George Russell and Richard Shea—fought at Breed's Hill.

Typical of them was Kincaid, "in Ireland a victim of the much-dreaded press gangs." He had "deserted the British flag and on offering his services to the Americans...was made a sergeant."

Another Kincaid, fourteen-year-old Samuel, Thomas's son, had joined his father in America, and on June 17, 1775, stood behind the American defenses as a drummer boy, willing to die alongside his father for their adopted cause. The elder Kincaid and the other Irish deserters proved welcome additions to the Rebels, for the Irishmen knew their way around muskets and cannons.

The Kincaids watched as the Redcoats surged in perfect order up the slope. They pressed forward, their bayonets flashing, their drums pounding. Suddenly Kincaid, Doyle and the other Rebels squeezed their muskets'

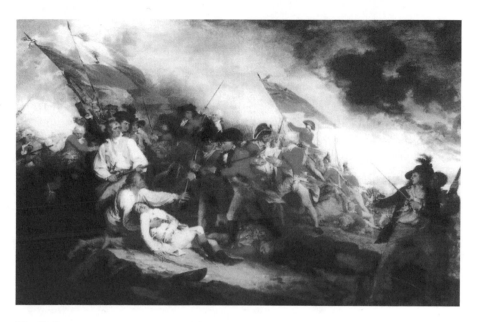

The Redcoats surge up the slopes of Breed's Hill, where a number of Irishmen were killed and wounded on both sides. *Painting by John Trumbull, Library of Congress.*

triggers, and the muzzles' din muffled the drums. Smoke shrouded the hill. As it slowly dissipated, the Redcoats were retreating, dead and wounded heaped along the grass. The Rebels' cheers followed the British down the hill.

As the Redcoats reformed their columns, the Patriots' cheers faded. Again the scarlet lines came on in perfect order to their drummer boys' cadence. For a second time, the Rebels held their fire with admirable discipline and then unleashed murderous blasts. The Redcoats staggered back down the hill, hundreds more screaming, writhing or lifeless across the slope.

Believing the battle over, a new round of cheers rose from the defenders. Then, slowly, through gaps in the smoke, the Rebels spied the Redcoats reassembled. The cheers ceased, and with the Patriots' realization that they were down to their last shots, dozens of men began to edge away from their posts.

Once more the British drums pounded. The columns marched over prone comrades up the slope. The Rebels' muzzles barked and felled dozens more Regulars. This time, though, the Redcoats swarmed over the defenses and plunged bayonets into the reeling Patriots. Daniel Callaghan and Thomas Doyle "literally flung themselves in the path of the advancing forces" to match bayonet thrusts with the British and perished in the melee of metal. Many of their fellow Irishmen also died in that final British charge; however, scores of others escaped to battle the Redcoats on other fields.

The Rebels had littered Breed's Hill with 228 British dead and 828 wounded—a staggering casualty rate of 42 percent (10 percent is considered high). Men with such names as Callaghan, Doyle, Kelley, Ryan, Donohue and Sullivan had done their part in the Rebels' ranks.

Among the Rebels who escaped the last British onslaught at Breed's Hill were the Kincaids. Both father and son survived the Revolution and eventually settled in Crawford County, Illinois, where Thomas lived to the age of 105. Samuel Kincaid, the Breed's Hill drummer boy, took up arms again against the British in the War of 1812.

Despite countless writers who tried to bury the exploits of the Kincaids and the other Irish-born men who fought at Breed's Hill, the truth is emblazoned upon the Memorial Tablets of the Bunker Hill Monument. There, alongside the names of Yankee Patriots, are those of their Irish comrades.

"Clear the Streets"
The Boston Irish Draft Riot

In his epic film *Gangs of New York*, Martin Scorsese captures the grim, violent world of the Irish trapped in the "rookeries" (tenements) of Civil War–era New York City. The film culminates with the July 1863 Draft Riot, the worst mass riots in American history, which were fueled by Irish immigrants' fury at the class and ethnic unfairness of the nation's first Conscription Act, which allowed "sons of wealth" to buy their way out of the draft for $300. The sum was far beyond the reach of impoverished Irish families.

Boston's Irish population held similar antipathy against President Lincoln's conscription and rose up in savage protest in July 1863. In Boston, however, there was a pronounced difference from what erupted throughout New York City. The Boston Irish did not run wild in a mass killing of African Americans, as did the Irish mobs of New York.

Early in the steamy afternoon of July 14, 1863, Provost Marshals David Howe and Wesley Hill knew they were in trouble. Serving Union army draft notes in Boston's Irish North End, the pair made their rounds with the dreaded papers at a time when many local men were at work or otherwise away from their flats. The officials' luck ran out at the lower end of Prince Street, where a drafted Irishman answered a door.

When Howe handed the Irishman his draft notice, his wife erupted with protests and curses at the marshal and flung herself toward him, her fists flailing at the stunned man. She, along with her immigrant neighbors, had seen many other fathers, sons and brothers march away in Federal blue, never to return from battlefields or surgeons' tables, or else to come back

The Irish tenements of mid-nineteenth-century Boston. *Boston Public Library.*

amputees. Acutely aware that the Twenty-eighth Massachusetts Regiment of the vaunted Irish Brigade had endured one of the war's highest casualty rates, many of the North End Irish had had enough of "Mr. Lincoln's War." Thousands of Irish immigrants pitted against free blacks for society's most menial jobs loathed the Emancipation Proclamation, which many Irish believed would flood Boston and other Northern cities with hordes of ex-slaves looking to take Irish jobs.

The Irishwoman accosting Howe not only railed against the thought of her husband fighting to free the slaves, but also denounced the pocketbook provision of the Conscription Act: draftees could buy their way out of the service by paying a "substitute" $300. Many immigrant Irishmen desperate to feed their families took the lethal "bonus" and, as Bostonians had just learned, in New York City's teeming slums Irishmen shouting "rich man's war, poor man's fight" had already unleashed bloody draft riots for two days previous.

The North End Irishwoman's shouts sent Howe backpedaling onto Prince Street and straight into a crowd of Irish laborers "away from their work this hour…in the narrow, crooked streets" near the Boston Gas-Light Company. To the horror of Howe and Hill, "the cries of the infuriated woman acted like a preconcerted signal upon the people in the neighborhood." Hill fled as the mob closed in on Howe. Burly workers slammed the official with clubs, boards, fists and feet, blood soon covering his head and face.

The din brought Police Officer R.H. Wilkins scurrying into the crowd with his billy club cracking heads left and right. Somehow he dragged the

dazed Howe to a nearby store and barricaded it until several more policemen arrived. The mob attacked them, and though the officers got Howe safely away, several more were savagely beaten, one of them "trampled upon and maimed for life." The Boston Draft Riot had begun.

By mid-afternoon, mobs stormed through the North End and soon surrounded the First Division Police Station. Scores of Irishmen poured from the gasworks and joined the siege. Historian Edward Harrington writes, "They proposed to test the question whether the Government had the right to drag them from their home to fight in a cause in which they did not believe."

Mayor Frederic W. Lincoln answered that question by dispatching troops to the North End, but had only a few units of militia and regulars from which to draw. A light battery of artillery was holding the Cooper Street Armory, a key point because of the weapons stored there. At 7:00 p.m., another company of artillery marched from Fort Warren through the mob, who jeered and threatened the troops, and into the surrounded armory.

As soon as the reinforcements barred the gate, the throng stormed the bastion, tearing up brick sidewalks and cobbled streets and hurling jagged stones at the armory's windows. A late-arriving officer named Lieutenant Savin tried to dash through the mob to the armory, but "was set upon, knocked down, and severely injured by kicks and clubs." Several soldiers with bayonets fixed rescued him.

The artillerymen wheeled out a six-pounder cannon loaded with canister shot—bits of metal used to tear apart massed troops—and ordered the crowd to fall back. For several minutes, the massed workmen complied.

Then, at 7:30 p.m., hundreds of North End Irish launched a second attack at the main door with "brickbats" as hundreds of other rioters hurled rocks and rubble through "every pane of glass." Once again officers pleaded with the crowd to disperse but were "received with hooting and hissing."

A company of soldiers rushed from the armory, snapped off a volley of blanks and drove the crowd at bayonet point a short way up Cooper Street and toward Charlestown Street. Then the troops wheeled around and marched back to the fortress with the crowd of cursing Irish following warily at a distance.

As soon as the soldiers "closed and fastened the door," the mob again attacked. The main door flew open and the muzzle of the brass cannon bristled at the rioters. Encouraged by the fact that the soldiers had fired only blanks from their muskets, the North Enders kept coming.

Suddenly the cannon belched "full in the face of the crowd." The hissing canister shot shredded the rioters' front ranks; several men were killed and others were writhing on the remnants of the cobblestones. The mob fell back again, but still made "riotous demonstrations just out of harm's way."

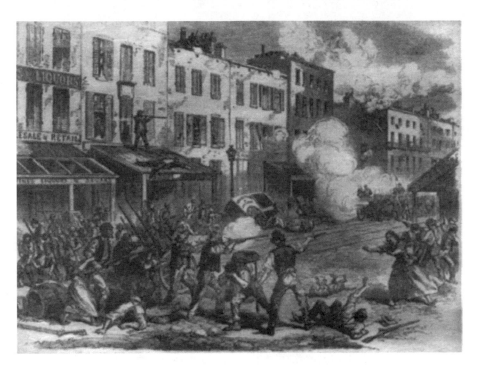

Rage against the Civil War Draft Act ignited a bloody riot by Boston's Irish in the summer of 1863. *Library of Congress.*

Inside the armory, the order to "clear the streets" sent several infantry platoons at the mob. The muskets barked once again, and this time .69-caliber Minie balls slammed into the Irish. Seventy-one-year-old William Currier, not a rioter, merely an onlooker, was slain by a ball that ripped through his side. An unidentified young Irishwoman lay lifeless on Cooper Street, a Minie ball having pierced her throat. A youth named McLaughlin "thrashed on the streets with wounds in his arms, shoulder, and chest until friends dragged him to a hospital." Scores of other North Enders were hit.

Realizing that clubs, bricks and cobblestones offered scant reply against Federal muskets and canister, the mob regrouped and stormed through narrow streets and back alleys to Dock Square, where numerous gun shops stood. The rioters smashed the shutters and door of one shop and grabbed pistols and cutlasses. Twenty-five policemen, with revolvers drawn, materialized at an adjacent gun shop and opened fire. Several rioters fell, and a ragged fray pealed across Dock Square until dragoons and infantry arrived and cleared the streets by 10:00 p.m. According to the *Boston Atlas*, however, "brick-bats were occasionally thrown at the soldiers and the police, and a few pistol shots were also heard."

The North Enders launched hit-and-run forays against the troops and the police for the next twenty-four hours. One rioter even sneaked onto the armory's roof and lit a fire, but soldiers quelled it before fire engines arrived. Throughout the tumult, Father Brady and other priests from nearby St. Mary's Church persuaded many parishioners to return to their homes, the clerics' courage winning the plaudits of the mayor and other Boston officials.

No one knows how many Irish were killed or wounded in the Boston Draft Riot, but the local newspapers ran the names of scores of wounded men, women and children of the "old sod" treated in Boston hospitals.

For several horrible hours on July 14, 1863, the fury of the Boston Irish at the draft had threatened to erupt with similar violence as the New York Draft Riots, but Mayor Lincoln's speedy and bloody reaction convinced many Irishmen "that it would be less hazardous to fight the Southern rebels than to fight Mayor Lincoln."

Some historians have assigned such ridiculously low figures as six Irish killed in the Boston melees. The true tally was undeniably much higher, but will forever remain a mystery because the rioters dragged away the bodies of slain neighbors and buried them in secret "without any official permit."

Anti-Irish officials of the day branded the riots as "hooliganism" pure and simple. While no one can deny that North End "roughs" eagerly joined the battle, many more rioters stormed the armory because they had surmised that the Conscription Act guaranteed that impoverished Irishmen were likelier to die on Civil War battlefields than middle- or upper-class native-born Americans able to come up with $300.

One local Irishman's words about the Boston Draft Riot summed up his neighbors' view: "I'd rather fight here, where I can go home to dinner, than in the Southern swamps."

"The Esteem of All Who Knew Him"

Patrick Guiney

On March 21, 1877, a gaunt, well-dressed man halted on a busy Boston street. He removed his top hat, sank to his knees, made the sign of the cross and collapsed. Brevet Brigadier-General Patrick R. Guiney, one of the city's best-known and most esteemed lawyers, died far from the some thirty-six Civil War battlefields onto which he had ridden or marched. His legacy marked a vibrant chapter in the history of the Boston Irish.

Patrick Guiney was born in Parkstown, County Tipperary, on January 15, 1835, and immigrated to the United States with his parents in 1842. He received the bulk of his education in the public schools of Portland, Maine, and went on to Holy Cross College in Worcester, Massachusetts. Keenly intelligent and ambitious, Guiney settled in Boston in 1855, studied law and passed the bar in 1856.

As his practice burgeoned, he fell in love with Jane Margaret Doyle, an attractive young local, and married her in 1859. The couple would have only one child, Louise Imogen Guiney, who was born in January 1861 and would go to on to become an acclaimed author, poetess and essayist in an era when few women were to able to launch full-fledged careers.

Patrick Guiney barely had time to settle into his new role of father before the outbreak of the Civil War compelled him to enlist in the Union army as a private. Though he started in the ranks for his first hitch and first endured the horrors of battle as a "lowly enlistee," his intelligence and pronounced ability to lead resulted in his coming back to Boston to help organize the Ninth Massachusetts Volunteers, who were largely drawn from the city's Irish neighborhoods. On October 24, 1862, he was commissioned a major.

With the Ninth, Guiney and his fellow Boston Irish saw some of the conflict's most savage action, and his performance on the battlefield earned him equal measures of acclaim and awe from his men and his superiors. Guiney's war records at the National Archives testify to his service: He was promoted to lieutenant colonel on July 28, 1862, for his valor at the Battle of Gaines' Mills, Virginia (June 27, 1862); "promoted to Colonel for service in the field, July 26, 1863; commanded the Second Brigade, First Division, Fifth Corps, most of the following year; he lost his left eye by a terrible wound in the forehead, at the Battle of the Wilderness, May 5, 1864; mustered out with the regiment; promoted Brevet Brigadier-General, March 13, 1865."

Those entries tell the facts of Guiney's service, but the words of his friend and fellow officer Major Daniel G. McNamara render a far more vivid portrait of the lawyer turned soldier. McNamara wrote:

> *Nothing redounds more to a soldier's credit for gallant and meritorious conduct on the battlefield than the commendation of his superior officer. Gen. Fitz-John Porter, commander of the Fifth Corps, Army of the Potomac, to which the Ninth Regiment belonged, recommended in special order Colonel Guiney for brevet commission for gallant services at the Battle of Gaines's Mills...*
>
> *After passing through the campaigns of nearly two years more, memory brings us vividly to the Battle of the Wilderness, May 5, 1864, under General Grant. Again the Ninth Regiment suffered terribly in killed and wounded. It was on that day that General Guiney fell at the head of his regiment with that terrible wound in his eye. The cruel bullet crushed through the eye down into head. Nothing but his splendid physique and strong vitality saved his life. The doctors declared he could not survive, that the wound was of so terrible a nature that it was only a question of time, and rather than attempt an operation it was in their judgment better to let him die without unnecessary pain. Not so with the general; although wounded nigh unto death, he still retained within his bosom all his native courage and indomitable pluck.*
>
> *Calling to his side, as he lay on the floor of the temporary hospital near the battlefield, Father Egan, chaplain of the Ninth, [Guiney] said: "Father, if you will find a surgeon on this field who will undertake to remove this bullet I will get better, for the longer it remains as it is, the worse for me."*
>
> *Father Egan, with his accustomed kindness, promptly secured the attendance of several surgeons from the hospital quarters. One among them agreed to undertake the operation, and in a comparatively short time, in*

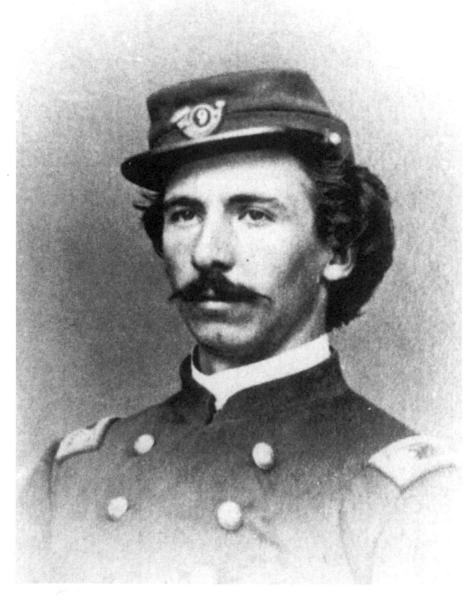

General Patrick Guiney, of the Ninth Irish Massachusetts Irish Regiment. *Holy Cross College Library.*

the presence of the other doctors, extracted the bullet, which proved to be a .59-caliber rifle ball. Under all his sufferings the general was patient, never complaining of his rude surroundings and poor accommodation. In the course of a few days he reached Washington, where his loving wife awaited him to nurse and attend him on his painful journey home. After weeks of suffering, and when only partially recovered, he met his regiment at the depot in Boston on return home for muster out, and rode at its head on its march to Faneuil Hall. Though time partly healed the jagged-wound, it eventually shortened his brilliant life, and ended the bright future that was before him.

It can be said of General Guiney that he was a brave soldier, a firm disciplinarian, a true friend, and a generous, warm-hearted officer. He was loved and respected by his regiment, and his recognized ability and uniform manliness endeared him to his comrades and associates through his life. While he loved his friends warmly and truly, he never harbored animosity against those who might exhibit unfriendliness towards him. His Christian training taught him to treat his fellows with Christian kindness, firmness, and forbearance. These traits of character carried him successfully through the difficulties that were to be encountered by a commander of volunteers in the army, and they won for him in after-life the esteem of all who knew him.

Back in Boston, Guiney resumed his legal career. He served as assistant district attorney for Suffolk County from 1866 to 1870 and was register of probate and insolvency from 1869 until 1877. He became one of the city's foremost advocates of the animal rights movement, "render[ing] able services to the cause of dumb animals while he was a district attorney, and won a case [for] the Massachusetts Society for the Prevention of Cruelty to Animals…His lofty and eloquent appeal for the dumb beasts was publicly admired and praised."

In contrast to his legal triumphs, Guiney struggled every day with chronic pain that hindered his health and stamina. His wound and the other effects of the war drained the attorney, and on March 21, 1877, his body gave out on that Boston thoroughfare. He was forty-two.

Dr. John G. Blake, one of Guiney's closest friends, penned a fitting eulogy to the departed hero:

In the long list of names that deserve commemoration for the honor done their native land, none justly stands higher than that of Patrick R. Guiney. A brave, fearless, and successful soldier who carried through his broken life, with a smiling face, the shattered constitution resulting

from wounds received in the service of his adopted country; a pure, able, and honest public official, and an estimable private citizen, he combined all the qualities that the most exacting friendship could ask for. Life to him meant earnest, soul-felt endeavor. Chivalrous, pure-minded, the personification of integrity, it used to be said of him that he stood so straight that he bent backward.

A man whose deep religious feeling permeated his life; free from narrowness, and broadly Catholic, he was a true and loyal son of Mother Church in the highest and fullest sense. In private life a devoted husband, a loving father, a fast friend, and delightful companion, his memory will live in the hearts of those who knew him best while life endures.

PART EIGHT

"SUFFRAGETTE CITY"

"The Grand Heckler"

Maggie Foley of Meeting House Hill

In 1911, Massachusetts Republican gubernatorial candidate Louis Frothingham had a problem. Everywhere he stopped on the campaign trail, a Boston Irishwoman made his life miserable. Cruising up to his rallies and speeches in a touring car dubbed the "Big Suffragette Machine," Margaret (Maggie) Foley was an unabashed crusader not only of the vote for women, but also for the trade union movement at the turn of the century.

Foley, sporting a yellow sash with the slogan "Women's Rights Now," badgered Frothingham to explain his staunch opposition to women's rights and to articulate his views on the plight of working men and women. Frothingham, unnerved by and weary of Foley's verbal challenges everywhere from Boston to the Berkshires, finally ordered his campaign band to boom out a tune every time Foley began to shout at him through her megaphone.

If the politician thought that mere drums and a brass section could drown out the voice of Maggie Foley, he was delusional. She spoke out for women and for "the little guy." Frothingham, Brahmins, Irishmen and Catholic clerics enraged by her "uppity" challenges to traditional views of the workplace and home failed to suppress the voice of Margaret Foley, "one of the most articulate and colorful champions" of the era's trade and suffrage movement.

Born Margaret Lillian Foley to working-class parents in Dorchester's Meeting House Hill neighborhood, she grew up in the 1870s and 1880s, graduated from public school and soon went to work in a hat-making factory. A life loomed of long shifts in alternately sultry and frigid factories,

marriage, family and struggle to keep the proverbial roof over one's head and food on the table.

The young factory girl from Dorchester chafed at the very notion of the traditional life she was expected to lead. Galled by the harsh conditions in the sweatshops for women, she embarked on a sojourn ending with a visit to a relative in California, where her athleticism earned her a living as a swimming and gymnastics instructor.

Always a neighborhood girl at heart, Foley eventually returned to Boston and even took back her old job at the hat factory. This time, however, she had not come merely to draw her meager wages. The trade union movement that galvanized laborers against bosses was gathering steam in Boston, most notably at first among working-class men. Foley espoused that "factory and shop girls" needed to demand better workplace conditions, fewer hours and better pay every bit as vociferously as the men. In short, she was poised to become a trade union agitator.

Foley had also embraced another controversial cause: to win the vote for women. The Meeting House Hill woman emerged at the century's turn into a full-fledged suffragette.

Foley's dual crusades cast her not only against factory owners and bosses, but also against the traditional roles of men and women in Boston Irish society. In the home, many Irishwomen ruled the proverbial roost, their husbands more than happy to have their wives handle "the mysteries of the kitchen, the living room, and the parlor." Parish priests also did their part to remind women that wife, mother and helpmate were their proper spheres—not political activist and trade unionist. Clerics railed against Irish Catholic women forging "unholy alliances" with suffragettes.

Margaret Foley dismissed all such warnings. Her passion for social change led her to the Massachusetts Woman Suffrage Association, where she embraced the organization's tenet that women's working conditions had to change inside the state's textile factories. Spearheaded by labor leader Mary Kenney O'Sullivan, one of the founders of the National Women's Trade Union League, the Massachusetts chapter battled the "inhuman octopus" of factory bosses and owners. From Boston to the mills of Fall River and New Bedford and to the plants of the North Shore and central and Western Massachusetts, Margaret Foley literally found her voice. She raised it on behalf of poor Irish-born and Irish American women whom Yankee bosses strove to "keep in their place" because they were Irish and Catholic. She addressed union and suffragette meetings and rallies and honed a formidable, articulate and biting style of speech.

Linking trade unionism and the vote for women, Foley asserted that once women could legally mark a ballot, they could affect humanitarian

changes in the factories. Wherever Massachusetts's anti-suffrage politicians mouthed their views, Margaret Foley generally turned up, and to the Dorchester activist, it did not matter whether the politicians were Brahmins or Irish ward bosses. Her debates with and tirades against male movers and shakers earned her the sobriquets the "Arch Quizzer" and the "Grand Heckler."

In the 1911 Massachusetts gubernatorial election, she turned the campaign into a nightmare for Republican candidate Louis Frothingham. Frothingham, a Harvard-educated nob and a power in the statehouse, had actually garnered the support of Boston Irish political powerbroker Martin Lomasney and his Irish Eighth Ward in an unsuccessful bid for governor in 1905; however, from Foley, Frothingham found nothing but derision and challenge. Roaring up to Frothingham's campaign stops in her "Big Suffragette Machine," emblazoned with her banner demanding "Women's Rights Now," Foley harangued him at every turn. She fired barbed questions at him on his views about women, the Irish and conditions in the factories.

If it had been Foley alone who showed up at the politician's speeches and rallies, he might have been able to deflect her verbal assaults. Wherever Foley appeared, though, her supporters gathered, and Frothingham also faced their jeers, catcalls and applause and cheers for "Maggie."

Eventually, Frothingham responded with a directive that his campaign band blare out a tune every time Foley began to speak. His ploy failed, as the band could not silence Margaret Foley and the shouts of "let her speak" from her supporters and other listeners alike. At least once on the campaign trail, her supporters rushed the band. The musicians scattered, dropping trumpets, trombones, tubas and sheet music everywhere, a drummer actually cringing behind his instrument. Due in no small part to Foley and her followers, Frothingham lost the race.

Foley did not confine her activism to New England. She traveled all over the country to speak for women's rights and for unions, and in 1914, when news came that a referendum on women's suffrage would appear on a statewide ballot in Nevada, she rushed there to campaign for the vote. She relentlessly barnstormed across the state, and to persuade silver miners that women should have a political voice, she put on a miner's helmet, coat and trousers, descended 2,500 feet into a Virginia City mineshaft and earned not only the men's support, but also several earnest proposals of marriage—all of which she graciously declined.

Foley's crusade led inevitably back to Massachusetts, where her oratory and tenacity continued to enrage factory owners, husbands from all strata of society and prelates such as Cardinal William O'Connell. Still she

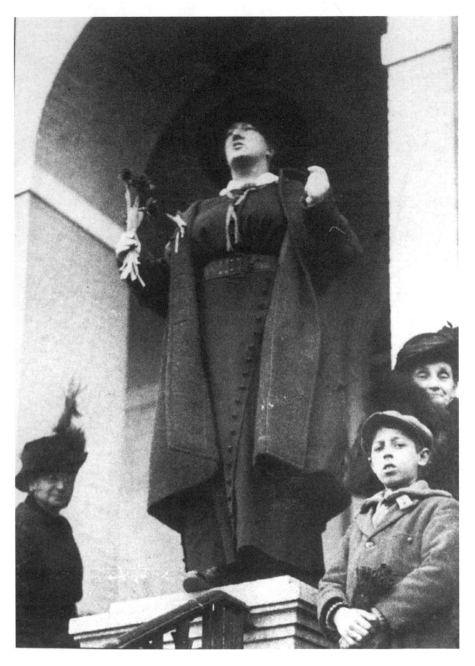

"The Grand Heckler"—Maggie Foley—orator and suffragette. *Library of Congress.*

pressed on, winning such allies as the Boston Red Sox, who, "almost to a man," backed her campaign to open the ballot booth to women. So popular was Foley with some of the players that they called a home run a "Maggie Foley."

Foley and other Massachusetts suffragettes' hopes rose with the support of Governor David L. Walsh, a Catholic and staunch advocate of women's rights, but the movement took a blow with the 1916 reelection defeat of Walsh and his proposed voting rights amendments to the state's constitution. Neither Walsh nor Foley gave up their crusade. He was elected to the U.S. Senate in 1918, and with his voice added to the growing support on Capitol Hill for the women's vote, the cherished goal of Foley and her fellow suffragettes was at hand.

In 1920, the passage of the Nineteenth Amendment brought Margaret Foley the culmination of her dream—the right to cast a ballot. From Meeting House Hill, to Beacon Hill, to Capitol Hill, Margaret Foley had stood up for the working class and for all women.

"The General Organizer"
Mary Kenney O'Sullivan

Few remember her name. Every time, however, that a Massachusetts woman casts a vote at the ballot box, she owes an incalculable debt of gratitude to Mary Kenney O'Sullivan. From the 1890s until her death in Medford in 1943, O'Sullivan, married to *Boston Globe* labor editor John F. O'Sullivan, spearheaded the labor movement and the battle for the women's vote in Massachusetts.

O'Sullivan's crusade for better conditions for female factory workers made her a prime player in settling the acrimonious Lawrence textile strike of 1912. Her other crusade, women's suffrage, sent her on the stump throughout the state, from the Boston wards to Western Massachusetts. The daughter of impoverished Irish immigrants, Mary Kenney O'Sullivan was handpicked by AF of L titan Samuel Gompers as the union's first female "general organizer" in 1892.

Mary Kenney was born on January 8, 1864, the second of Michael and Mary (Kelly) Kenney's four children. Her parents had emigrated from Ireland in the 1850s and were married in Concord, New Hampshire. Working as a railroad machinist, Michael Kenney and his family ended up in Hannibal, Missouri, where his nine-year-old daughter excelled academically at a convent school, but was frustrated that the fourth grade was "as far as any children of wage earners were expected to go." To her dismay, the intelligent young girl was apprenticed to a dress maker.

Further slamming her hopes that she might somehow escape a life in a sewing factory or a mill, her father's death left Mary and her siblings with the task of providing for their invalid mother. In her teens, Mary went to

work for a printing and binding company. Her intelligence, her industry and her "personal charm—she was five feet six inches tall, with golden red hair and bright blue eyes"—led to her eventual rise to plant forewoman.

In the late 1880s, Kenney moved to Chicago and found the perfect direction for her ambition and her intellect: the labor movement. She became a vibrant voice not only for women's rights in the workplace, but also for the crusade to win women's suffrage.

Kenney unionized Massachusetts women working in print shops, shoe factories and carpet plants. While staying with a friend in Boston in the summer of that same year, she met John F. O'Sullivan, the *Boston Globe*'s labor editor, who fell head over heels for the pretty, driven Kenney. She felt the same about the former seaman and streetcar driver turned activist and journalist. Because both were heavily immersed in work, they delayed their wedding for nearly two years, finally taking their vows on October 10, 1894.

Mary and John O'Sullivan made their home in Boston, and Mary made the plight of poor Boston Irishwomen laboring in the factories a large part of her mission. She organized the Union for Industrial Progress, which blew the whistle on sweatshops' abusive practices against women in the workplace.

To better grasp how deplorable conditions were for women in several of the wards' tenement districts, Mary and her husband lived in one of the most ramshackle buildings, Denison House, for several months. The eye-opening experience led her to found a summer camp in Winthrop, where young Boston Irish working women could escape the unhealthy slums and factories on weekends.

Tragedy tore into Mary Kenney O'Sullivan's life in September 1902. In Lynn, John O'Sullivan stepped off the wrong side of a train and was run down by another. His widow refused to wallow and let grief engulf her and the couple's three children; she knew that she could not afford self-pity. She plunged back into activism full-force. Among her many causes was the Improved Dwelling Association's Ellis Memorial, a model tenement for poor Irish and other immigrants in South Boston. In the building's basement, she taught English to children and sanitary housekeeping to their mothers. She was also one of the chief figures in settling the vitriolic Lawrence textile strike of 1912, her round-the-clock efforts on behalf of the female factory workers ending with sizeable wage increases for the strikers.

At the same time, O'Sullivan was pushing hard for women's suffrage, organizing and delivering powerful speeches all over the state, her blue eyes flashing as she harangued male opponents of suffrage. She enlisted recruits

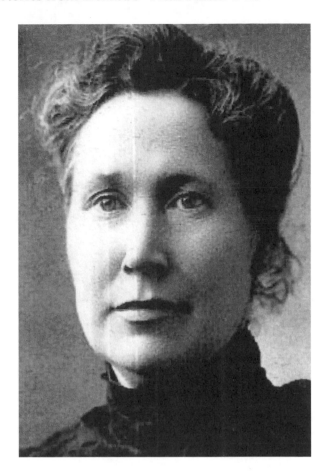

Suffragette and union lioness Mary Kenney O'Sullivan, "the General Organizer." *Library of Congress.*

from the wards of Western Massachusetts, and her supporters turned out for mass rallies, waving signs and placards in demand of the ballot.

When women from Boston's Irish neighborhoods and Brahmin brownstones alike walked to the voting booth for the first time in 1920, Mary Kenney O'Sullivan's impact loomed large. So, too, did her legacy resound in 1960, when women from coast to coast helped elect America's first Irish Catholic president, John F. Kennedy.

Mary Kenney O'Sullivan died of heart problems in 1943 in her West Medford home and was buried in St. Joseph's Cemetery in West Roxbury. The daughter of impoverished Irish immigrants, a crusader to the last, she merits far more remembrance than she has received.

PART NINE

LET THE GAMES BEGIN

The Boston Irish "Rocky"

Jake Kilrain

In the late nineteenth century, a Boston Irishman brawled his way to the forefront of the brutal world of bare-knuckled boxing. He was not, however, "the Great John L. Sullivan." His name was John Joseph Killion—known to the fight world as Jake Kilrain, the "basher" who went toe-to-toe with Sullivan for seventy-five rounds in 1889 and always believed he [Kilrain] "was robbed" in the immortal bout.

"Disappointment was the lot of John Kilrain…the man who might have been heavyweight champ of the world," a *Globe* article postulated. Boston's other "strong boy" would never escape Sullivan's imposing shadow.

John Joseph Killion was born the son of immigrant Irish parents in 1859 in Long Island, but the family soon moved to Somerville, Massachusetts. In the tough, working-class neighborhoods there and in Boston, Killion grew into a quiet young man, "an attentive listener" who was "never a man to talk about himself." His fistic skills, however, convinced neighborhood toughs to look elsewhere for trouble, and when he began pounding local prizefighters in the ring in the late 1870s and early 1880s, he caught the eye of boxing promoters and partners Richard K. Fox and Billy Madden.

Madden, who had once trained John L. Sullivan, and Fox, a publishing magnate who had futilely tried to wrest Sullivan from his handler, Bostonian Jim Keenan, had been beating boxing's proverbial bushes for a heavyweight who could walk into a bout against Sullivan with a chance to "blast the champ's crown from his head." Their crusade had proven a bloody litany of failure: "They tried everyone, from Englishmen and Irishmen down to New Zealander Herbert Mauri, a hulking giant who had actually turned

and run" when confronted by John L. To the pair of promoters' financial distress in the "winner-take-all" world of prizefighting, Sullivan pummeled their finds "as fast as they were found."

In 1884, after a sinewy, fearless young heavyweight had left a string of opponents flat on their backs in Boston arenas and in Madison Square Garden, Fox and Maddox began to size up the rising brawler, whose ring moniker was Jake Kilrain.

The promoters convinced Kilrain to let them guide his career, but knew that while he was already a "better than average ringster," he needed more seasoning before a bout with Sullivan. Fox and Madden put their young charge through months of grueling training, Kilrain running and rowing to build up his brawn and wind and sparring skills under Madden's relentless eye. Then, in 1887, Fox's popular publication *Police Gazette* proclaimed Boston's "latest" young Irish fighter "the new heavyweight hope" and challenged Sullivan to a bout.

After murky negotiations in which an actual agreement may not have been signed, Sullivan apparently agreed to fight and suddenly backed out because the broken arm he had suffered in his victory over Patsy Cardiff had not healed completely.

On the front page of the *Police Gazette* and in other newspapers, Fox charged Sullivan with breach of contract and claimed that Jake Kilrain was the new heavyweight champ of America through John L.'s "forfeit." Then, to the rage of the recovering Sullivan, Fox strapped "the famous *Police Gazette* belt" around Kilrain's waist, "announcing to all and sundry that Jake was the best fighter in America"—without having thrown a punch at the real champ. Sullivan went out and bought a more expensive title belt for himself. The seeds of one of boxing's most famous feuds had been sown and would take violent root.

With the controversy trailing them, Kilrain and Sullivan both sailed for England to fight for the heavyweight crown of the British Isles. Adding more vitriol to the feud, the British title was disputed between Jem Smith and Charles Mitchell, and when Sullivan signed to fight Mitchell, Kilrain agreed to take on Smith in Rouen, France, for the "world championship" and a huge purse of $10,000. Fight day was scheduled for December 19, 1887.

In Boston Irish neighborhoods, wagering ran heavily in favor of "the local lad" against the burly Brit, whose massive knuckles had bludgeoned far larger men than Kilrain into a stupor. If, as fight experts expected, Smith tore apart the relatively inexperienced Boston Irishman, Sullivan need not concern himself with Kilrain any further.

On the day of the fight, a snowstorm stuck Rouen and blanketed the bout's site, the Isle St. Pierre. By the time work crews had shoveled out the ring, late afternoon had descended and both fighters were shivering,

stamping their feet and blowing on their scarlet knuckles in a hopeless attempt to keep warm. A throng of fans waited patiently in the cold, having paid steep ticket prices of up to fifty dollars and having laid down sizeable bets—mainly on the Englishman.

Finally, as twilight approached, the fighters were "called to scratch," the center of the ring, and squared off. Then, for 106 rounds, Kilrain and Smith slipped and slugged away at each other, bare knuckles turning both faces into a latticework of gashes, black eyes and broken noses. With each shot to ribs, solar plexus and stomachs, bruises spread, the fighters' grunts and cries punctuating each blow landed or received.

At the end of those 106 rounds, Kilrain had defied the experts—he was still standing. So, too, was the relentless Englishman. Darkness ended the bout in a draw, Kilrain pocketing half the purse.

The battered Boston Irishman returned to America "in a blaze of glory," and fight fans' pressure for a duel between Boston's "Irish titans" soared. Not until 1889 could the two fighters' camps come to an agreement; then, Sullivan, eager to slap down Kilrain once and for all, agreed to "the battle of the century," set for early July 1889 "in or near New Orleans."

Secrecy cloaked the arrangements of the bout, for most states had outlawed bare-knuckles boxing. The fighters and their entourages boarded a specially hired train to Richburg, Mississippi, and finally, near dawn of July 8, 1889, the bout for which Irish Americans and all fight fans alike had clamored loomed as both boxers, stripped to the waist, stepped into the ring. Although the fight's early start was supposed to avoid the Delta heat, the temperature was already pushing toward one hundred.

Because of the laws against bare-knuckles prizefights, Kilrain and Sullivan did wear gloves—"but as they were of the skin-tight leather variety, they might well have been bare knuckles." For seventy-five rounds, the combatants tore each other up with those flimsy gloves, both men reeling both from each other's punishment and from an equally formidable foe: the heat. Three thousand sweltering fans cheered "boxing's boyos" from start to finish of each round.

At the end of the seventy-fifth round, a ringside doctor reportedly pulled aside Kilrain's second, Mike Donovan, and said, "That man'll [Kilrain] die if he keeps it up."

Across the ring, Sullivan, bruised, bloodied, gasping in the sultry air, was in no better shape.

Whether out of concern for his fighter or some other, less laudable reason— rumors were rife that Donovan had placed a bet on Sullivan—Donovan tossed a sponge into the ring, "indicating that his man had given up." The referee immediately stopped the bout and awarded Sullivan the decision.

John L. Sullivan (right) and Jake Kilrain (left) pound away at each other in the ring.
National Police Gazette.

The stunned Kilrain and his promoter Fox pleaded with and ranted at the referee to ignore the sponge, but the epic battle of the Irish American boxers was over. So, too, was the era of bare-knuckles boxing in America.

The embittered Kilrain never forgave Donovan. "There has always been talk about that fight," the boxer later said, "because a second threw in the sponge...He had no right to do so without consulting me...We were both exhausted. We could not have landed a punch at that stage that would have hurt, let alone knock an opponent out. It was just a matter of sticking."

Kilrain had proven one of the few fighters utterly unafraid of the great John L. Sullivan, but the pair would never box each other for real again. Kilrain waded into the ring until 1895, but retired after the much younger Steve O'Donnell throttled him in a Coney Island bout. At thirty-six, Kilrain had taken enough punishment. He had battled not only Sullivan, but virtually all of the era's best on both sides of the Atlantic, pounding out a reputation as one of the nineteenth century's hardest hitting, most resilient boxers.

Ironically, Kilrain and Sullivan became "fast friends" in their post-ring days and remained so until Sullivan's death in 1918. Unlike his one-time foe, Kilrain sought a life out of the limelight, moving to nearby Quincy and taking a job as a watchman at the Fore River Shipyard. He rarely, if ever, attended prizefights, "because when [I] am spotted, I am asked to take a bow." Further eschewing publicity, he went by his real name, John J. Killion. "I've tasted all the fame," he said, "and should now step down in favor of younger men."

In contrast to many boxers of his own and future eras, Kilrain did not squander his winnings and lived comfortably for the rest of his long life. A devoted father and grandfather, he became a passionate cribbage and checkers player, a far cry from his pugilistic past. Still, even though he tried to put the past behind him, boxing writers and fans never forgot the man who had climbed into the ring with John L. Sullivan and had given all he could handle. Kilrain's home became a "Mecca for sports followers…who remembered the day when he was one of the noted athletic characters."

Jake Kilrain passed away on December 22, 1937, at the age of seventy-eight. To his dying day, he believed that the infamous sponge episode of July 8, 1889, had cost him the heavyweight crown: "I thought Sullivan would not come out for the round, but the sponge ended it…The records carry Sullivan as the winner."

The records did, but not Kilrain himself.

"The Wollaston Whiz"

Tom McNamara

He rose to acclaim as one of the "Homebreds," the first golfers to put America on the game's map in the early twentieth century. One of the best in those early years was Tom McNamara, "Tommy Mac" to his family, friends and foes on the links.

McNamara long held the "always a bridesmaid" tag in the U.S. Open of his era, a "crown" unhappily worn in later generations by the likes of Sam Snead and Phil Mickelson. McNamara was a Boston Irishman who worked as the pro at local courses (the old Wollaston, for one) and who, in 1916, was one of the founding fathers of the PGA.

Admired as one of the finest shot makers of his time, he crafted several of the more memorable rounds in Open annals, but always fell a shade short when the final rounds were tallied. Frustration? McNamara finished second in three Opens: 1909, 1912 and 1915; in the latter tourney, he lost by one stroke to Jerry Travers. He also notched Top 20 finishes in seven other Opens. Similarly, Mickelson was the runner-up in 1999, 2002 and 2004.

Many golf historians would contend that despite his Open frustrations, McNamara did not come up empty in the majors because of his triumphs in the 1912 and 1913 North and South Opens. In the pre-Masters, pre–PGA Championships days, players and scribes alike viewed the North and South as a major.

In various accounts over the years, golf writers have stated that McNamara was born in Lahinch, Ireland, but local researcher Albert Greene, who has traced McNamara's career through the United States Golf Association and

Local golfer Tom McNamara was one of the game's finest shot makers of the early twentieth century and a founding father of the PGA. *Boston Public Library.*

other sources, has spoken with one of McNamara's great-granddaughters; she relates that the golfer was born in America.

Greene writes, "It seems that Tommy Mac…was not born in Lahinch. More than likely his parents hailed from Lahinch, and I am trying to get some documentation on this." Greene has located a 1922 Ellis Island notation of a Tom McNamara who was born in Brookline on November 18, 1882, and lived in Mount Vernon, New York. McNamara did live and teach the game there in his later career.

Greene has a clipping of a *Professional Golfer of America Magazine*'s obituary for McNamara, and it provides a glimpse of the Irish American golfer, who learned the game in Brookline as a caddie and went on to become one of the game's most notable "Homebreds." The notice relates:

> *Tom McNamara Dies Suddenly*
> *Professional golf had to endure another unexpected loss in the sudden death to heart failure of Tom McNamara at his home in Mount Vernon, New York, on Friday, July 21* [1939].

One of the veteran homebreds, "Tommy Mack [sic]," as his friends called him, developed his game as a boy in the Boston district, and it wasn't long before he began to show prominently as a player...because of a business connection with the Wilson Sporting Goods company, he spent much of his time on the road, his business trips taking him to all parts of the country. As a result, he was known by golfers everywhere.

McNamara gained competitive laurels in many tournaments and attracted nationwide prominence in the national open championship...

Never a long driver, Tommy Mack [sic] made up for [it] with an exceptional short game, and his deadly putting and accurate approaches were the envy of his associates. Only a week before his death he was [at a tournament] *reminiscing with other old-timers of incidents long ago.*

McNamara was 57 years old.

At fifty-seven, McNamara was hardly an old-timer. His legacy lives on with the PGA, the organization that he helped found and that literally changed the landscape of the game for touring and teaching pros.

PART TEN

HOME FOR THE HOLIDAYS

Celebrating in Style

The Charitable Irish Society and America's First St. Patrick's Day Gathering

On March 17, 1737, in the heart of Puritan Boston, twenty-six men gathered to commemorate a decidedly Improper Bostonian event. They were Irish-born men living in a place where most locals loathed anything that smacked of "Popery," and celebrating a Catholic saint's holy day could well have proven a risky proposition.

The reason that the twenty-six men pulled it off was that they were Protestant; however, since some were formerly Roman Catholics who had "embraced" a new faith, their devotion to Protestantism may have been wan. The religious question aside, the men drew up a charter that professed their pride as sons of the Emerald Isle, and they were meeting on the day dedicated to Ireland's patron saint.

Their charter read:

> *Whereas Several Gentlemen, Merchants and Others, of the Irish Nation residing in Boston, in New England, from an Affectionate and Compassionate concern for their countrymen in these Parts, who may be reduced by Sickness, Shipwreck, Old Age and other Infirmities and unforeseen Accidents, Have thought fit* [sic] *to form themselves in a Charitable Society, for the relief of such of their poor and indigent Countrymen...*
>
> *That all Gentlemen, Merch*[ants] *and others of the Irish Nation, or Extraction, residing in, or trading to these Parts, who are lovers of Charity and their Countrymen, will readily come into and give their Assistance to so laudable an undertaking.*

The first St. Patrick's Day celebration of the Charitable Irish Society was underway. To become members, men had to be reasonably successful and "natives of Ireland, or Natives of any other Part of the British Dominions of Irish Extraction, being protestants, and inhabitants of Boston."

Of the first members of the Charitable Irish Society, historian James Bernard Cullen writes, "An important part of the membership of The Charitable Irish Society was the Irish Presbyterian Church, established in Boston in 1727. They first worshipped in a building which had been a barn on the corner of Berry Street and Long Lane [now Channing and Federal Streets]; and this unpretentious building served them, with the addition of a couple of wings, till 1744."

Despite Boston's vehement prejudice toward Catholics of the eighteenth century, the society ignored the religious restriction in 1764, after a historically short term of twenty-seven years. The members officially removed the Presbyterian requirement in 1804.

Who were the twenty-six original members who assembled on March 17, 1737? Virtually nothing remains in the historical record of some of these men aside from their names, and many of the names are undeniably Anglo-Irish or the so-called "Scots-Irish." Among the Duncans, Walkers and other such surnames of the original twenty-six are such unmistakably Irish names as Walsh and Neal.

The society held a dinner each St. Patrick's Day, toasting the old country and even its patron saint, until the coming of the American Revolution. Then, a split between members espousing the Patriot cause and those remaining Tories, loyalists to the Crown, put the annual March banquet on hiatus. Not until the end of the war, with victory at Yorktown, did the Charitable Irish begin to regroup.

One of the society's stalwarts, Captain William Mackay, described as a "gentleman" (i.e., not engaged in business) in the *Boston Directory* of 1789, had worked for the Rebel cause in Boston throughout the conflict. He lived on Fish Street and, in 1772—three years before Lexington and Concord—was appointed to a committee that devised a statement of the colony's rights and grievances. Before the war's outbreak, he was elected to the presidency of the Charitable Irish Society, a post he would hold until succeeded by Simon Elliot in 1788.

According to an admirer, "During the revolutionary period he [Mackay] enjoyed to the fullest extent the confidence of townspeople, serving on many committees for various purposes. Among other things he was a member of the 'Committee of Correspondence, safety, and inspection,' appointed by the town in 1776."

In October 1784, Mackay convened the first meeting of the society since the beginning of the war. The organization's minutes record his speech's introduction:

> Gent [sic] *Members of the Charitable Irish Society, I congratulate you on this Joyful Occasion, that we are assembled again after Ten years absence occasioned by a Dreadful and ruinous war of near Eight years; also that we have Conquered One of the greatest and most potent Nations on the Globe so far as to have peace and Independency. May our friends, countrymen in Ireland, Behave like the Brave Americans till they recover their Liberties.*

Mackay's patriotic words, with references to both America's hard-won freedom and Ireland's dreams of independence, were preached to the proverbial choir, as the body's Tories were long gone, having fled to Canada or Britain. Once again, the society embraced its traditional St. Patrick's Day gathering.

Another event, the 1833 visit of President Andrew Jackson to Boston, found influential Charitable Irishman James Boyd delivering a memorable address in honor of Jackson.

Four years later at the Charitable Irish Society's centennial celebration, held on March 17, 1837, not only were the members in attendance, but also a special list of guests composing a who's who of Boston's movers and shakers: "Governor Edward Everett, Mayor Samuel A. Eliot, Hon. Stephen Fairbanks, President of the Massachusetts Charitable Mechanic Association, the Rev. Mr. John Pierpont, the Hon. John P. Bigelow, Hon. Josiah Quincy, Jr." and numerous other luminaries.

Fairbanks delivered an address testifying to the fact that Boston Irishmen, Protestant and Catholic, were indeed making their way in the city:

> *The relation which you yourself Mr. President, as well as some others whom I have now the honor to address, sustain to that institution is some indication of the readiness of its members to avail themselves at all times of the friendly aid and cooperation of the intelligent and scientific, to whatever nation they may belong, and more especially of the natives of that country from which we have derived some of our earliest impressions of the importance of cultivating the arts. The liberal policy of that institution in regard to the admission of members is worthy of all praise, and the great accession of members, from time to time, is the best proof of the wisdom of this course, and I trust it will never subject itself to the imputation of reflecting any high-minded, intelligent mechanic, who has compiled with the conditions of the constitution, whether a native or adopted citizen.*

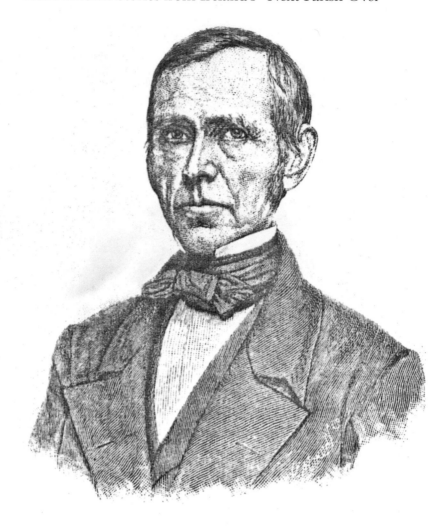

In the 1830s, James Boyd was a prominent member of the Charitable Irish Society. *James B. Cullen,* The Story of the Irish in Boston.

At the society's 125th St. Patrick's Day gala, on March 17, 1862, the second year of the Civil War, a commemorative address revealed that, as in 1775, men of the Charitable Irish had again answered their country's call:

> *A good many of our members have gone to the war to fight for the restoration of the glorious Constitution and Union of the States. Several of them, we can mention with pride, have already obtained a position in the army of the Union, which has redounded to the honor of their nationality. Thomas Cass and Patrick R. Guiney may be named in this record, the*

By the early 1900s, the Charitable Irish Society's annual St. Patrick's Day Celebration—America's first and oldest (1737)—had grown in stature to include a who's who of Boston's movers and shakers. *Archdiocese of Boston Archives.*

former Colonel, and the latter, Lieutenant Colonel of the 9th Massachusetts Volunteers, which regiment, we are proud to say, composed entirely of Irish and Irish extraction, is today one of the best and bravest on the soil of deluded Virginia.

Today, the tradition that began on March 17, 1737, remains strong. The Charitable Irish Society holds a unique place in the annals of the Boston Irish and Irish America alike.

On the March

Boston's First St. Patrick's Day Parades

The Parade. In Boston, the phrase means one thing—South Boston's annual St. Patrick's Day Parade. It all started officially in 1901, but the procession that so many enjoy today did not arrive easily for the Boston Irish, who long had to battle prejudice before they could have their celebration. Have their parade, Boston's Irish would, and proudly so.

As Irish Catholic immigrants landed in Boston in ever-increasing numbers in the 1840s and staked their claim to a new life in America, they soon thumbed their collective nose at Yankee antipathy to any commemorations of St. Patrick's Day. One of the early manifestations of the local Irish love for their old sod's patron saint was the Shamrock Society, a social club that gathered on March 17 to defiantly toast the saint and "sing the old songs," the revelers' voices pealing from Dooley's, the Mansion House and Jameson's. No single building, however, would long serve to hold the growing numbers of local Irish longing to celebrate the day in a bigger way. A historian noted, "No banquet room was broad enough to comprehend all the Sons of Erin, even had they the price of dinner."

There was only one way, Boston Irish leaders decided, to include not just Irishmen, but also women and children, in a celebration of St. Patrick. The solution was a parade.

As early as 1841, without official sanction by Boston's government officials, more than two thousand local Irish marched through the North End, their bands booming and crowds singing. Earlier, they had honored their patron saint at a traditional Mass. Religion and festivity were the order of the day for the impoverished immigrants, reflecting a wistful yet often

raucous longing for a bit of Ireland in their new homes. The scenes enraged many Yankees who still espoused their ancestors' loathing of anything Catholic—especially Irish Catholic.

The cant of Brahmins who reviled the St. Patrick's Day Masses and revelry notwithstanding, the Boston Irish prayed and paraded on March 17. St. Patrick's Day commemorations became so much a part of Irish life in the city that on March 17, 1863, the Twenty-eighth Massachusetts Regiment—composed of Boston Irishmen fighting and bleeding for the Union in the Army of the Potomac—celebrated the saint's day with their fellow regiments in the vaunted Irish Brigade. An Irish infantryman from Charlestown recalled that the unit's songs, toasts, horse races, speeches and an impromptu "stage show" that day all celebrated Ireland and its religious symbol. As historian Dennis P. Ryan assesses in *Beyond the Ballot Box*, the Boston Irish,

> *having dispelled the popular suspicion surrounding their allegiance to the Union by fighting in the Civil War…asserted their new sense of belonging by turning their patron saint's feast day from a religious to a more secular event. Some chose to observe the day by attending temperance banquets, where toasts to Ireland were made with "sparkling water," while others celebrated at parish socials, music concerts, saloons, and theaters, which featured Irish plays for the entire month.*

Still, the unofficial St. Patrick's Day parades that wound through every Irish ward from the 1870s to the 1890s proved the highlight of the festivities, bands and marchers tramping proudly through the heart of Boston, South Boston, Charlestown and Dorchester alike. All along the route, hordes of spectators lined the pavement, and Irish homes and businesses were emblazoned with colorful images of St. Patrick and draped with sheets or banners that were adorned with such traditional slogans as "Erin Go Bragh" and "Cead Mile Failte."

On March 17, 1886, Hugh O'Brien, Boston's first Irish-born mayor, infuriated the Yankee nabobs of Beacon Hill with his decision to close the Boston Public Library in honor of the revered saint and the celebrations in his name.

As much a part of the local landscape as the St. Patrick's Day parades and other celebrations had become from 1841 to the turn of the century, the hard-won traditions were about to evolve into something far more, something that truly proclaimed the growing clout of the Boston Irish. In South Boston, the biggest and best of March 17 celebrations would materialize.

John "Honey Fitz" Fitzgerald riding in a turn-of-the-century St. Patrick's Day Parade in Boston. *Boston Public Library.*

St. Patrick's Day parades organized by the Ancient Order of Hibernians, which numbered some eight thousand members in Boston alone by 1900, had become the norm. Bands, organizations, refreshments—all were handled by the Hibernians' Entertainment Committee. In the hands of Ward 17 boss "Pea Jacket" Maguire and other Boston Irish leaders, fun, festivities and pride in Irish roots ruled the city on March 17.

In March 1901, the blare of bands and the vibrations of marchers' feet pealed above South Boston's streets. Banners awash with glittering shamrocks, harps and images of the patron saint himself nodded in the gusts racing in from the Atlantic. The date, however, was March 18—with good reason. The city's leaders had sanctioned South Boston's first official St. Patrick's/ Evacuation Day Parade for the eighteenth because the seventeenth had fallen on Sunday and was subject to the Blue Laws. On that Monday morning, bands and colorfully uniformed militia, sailors and marines formed neat ranks along Q Street (Farragut Road), shivering with each spray-laden blast from the Atlantic that whistled across Marine Park and City Point. However, the chill did not keep away the crowds who jammed South Boston. Marchers needing a dose of warmth dashed into the haven of the Head House.

The procession commenced with a rattle of drums, the cries of pipes and the pounding notes of brass bands. Wave after wave of marchers poured onto Southie's streets, wound across the bridge and surged into downtown Boston to the ear-throbbing cheers and applause of thousands massed

Mayor Hugh O'Brien, who supported St. Patrick's Day parades, to the dismay of Brahmin Boston. *Bostonian Society*.

along the parade route. In their biggest outpouring of pride in a parade to date, Boston's Irish reveled in their heritage, a legacy with one foot planted firmly in America, the other in their ancestral counties. The words of a reporter rang true: "Let us think of the procession and the pageant, of the harp and the sunburst, of the cheerful lads and blushing lasses and of the rich brogue…full of heart and soul, all compact of significance and enthusiasm—an outpouring of genuine, rejoicing, a boiling over, in a word, of jovial patriotism and effervescent vitality."

That patriotism and "Irish pride" reached a throaty crescendo at Faneuil Hall as the parade's rousing climax erupted amid music and seemingly ceaseless applause. The first official South Boston Parade was over, but the post-march celebrations were merely beginning. Dignitaries in natty overcoats and top hats, figures such as Mayor Thomas Hart, stepped from the open, horse-drawn carriages in which the city's "high and mighty" had ridden in the parade and dashed into venerable Faneuil Hall for an official St. Patrick's Day banquet.

It was hardly the politicos alone whose party went on after the parade. Hordes of marchers and spectators streamed back to South Boston. At parish halls, in private homes and watering holes throughout the ward, the celebration of "all things Irish" continued. A throng of Boston Irish jammed every inch of Gray's Hall, nestled at the junction of I and Emerson Streets, for the South Boston Citizens' Association banquet. In an address that left the crowd misty-eyed, Congressman Henry Naphen waxed eloquently about the meaning of St. Patrick's Day and the growing role of the Irish in America. Inside that crowded, alternately boisterous and hushed room, the future of South Boston's annual St. Patrick's Day Parade truly materialized.

A newspaper column captured the essence of Southie's St. Patrick's Day Parade past, present and future: "A sign that, although scattered far and wide, Irishmen still hold to their love of country and countrymen, and never forget the verdant home they fondly call the gem of the sea."

In Boston, those sentiments and the legacy of the Hibernians, the marchers from the 1840s to 1901 and every other local expression of Irish lineage bloom especially on St. Patrick's Day. Beyond those sentiments, the "Irish holiday" has become something far more from Southie to San Francisco. As Edward Wakin notes in his book *Enter the Irish-American*, "The Irish had not only won acceptance for their day, but persuaded everyone else to join in, an achievement matched by no other immigrant group."

The Irish World, in the late nineteenth century, posed the following question: "How Long Will St. Patrick's Day Live Among Irish-Americans?" An editor answered:

> *While in veins of Irish manhood flows one drop of Irish blood;*
> *While in hearts of Ireland's daughter beats true Irish womanhood;*
> *While God sends to Irish mothers babes to suckle, boys to rear;*
> *While God sends to Irish fathers one man child thy name to bear.*

In Southie on every St. Patrick's Day, those sentiments and traditions still flourish as the bagpipes' skirl heralds the start of the Big Parade.

"Bah, Humbug"

Christmas for the Boston Irish

From 1800 to 1850, Irish immigrants could scarcely have picked a worse place than Boston to celebrate Christmas. The Puritans had loathed "Popish" Yuletide rituals so much that, in 1659, the Massachusetts General Court had enacted laws against honoring the day. Anyone caught toasting the occasion suffered a five-shilling fine. Above all, for the Mathers and other Puritan luminaries, Christmas celebrations symbolized "Papists" and their church. So entrenched did Bostonians' antipathy toward Catholicism become that the city's public schools were open on Christmas Day until 1870.

In such a climate, Boston's Irish celebrated the holiday in muted fashion until their political clout swelled in the late 1800s. On the "old sod," the holiday had largely revolved around Mass and family, not the raucous celebrations of any feverish Puritan and Yankee imaginations, so the early Irish of Boston noted the holiday simply, with many families keeping children home from schools later in the century.

At St. Augustine's, in South Boston, and later at the Cathedral of the Holy Cross, Christmas Masses were held in the opening decades of the nineteenth century, always under suspicion of the local Yankees. As German Catholic immigrants arrived and began attending the local "Irish churches," the newcomers introduced locals to Christmas trees and greeting cards; a thaw in the region's traditional, Puritan-steeped Christmas notions was slowly emerging.

The Christmas season of 1887 brought a "holiday" card that inflamed Irish from Dublin to Boston. The card, issued by Angus Thomas and entitled "Ode

Powerful Puritans such as the Reverend Cotton Mather banned celebrations of Christmas. *Library of Congress.*

to the Specials (police)," belittled the largely Irish crowd that had gathered at Trafalgar Square on November 13, 1887, to protest the imprisonment of Irish MP William O'Brien. Thrown in jail for having orchestrated riots against landlords, O'Brien had become a hero to his countrymen in both Ireland and Boston not only for his stand against the rent collectors and their agents, but also for his refusal to wear prison clothing and his campaign to wrangle political prisoner status for fellow Irishmen in British cells.

On Sunday, November 13, 1887, a throng defying Commissioner of Police Sir Charles Warren's ban on open-air meetings assembled at Trafalgar "to demand the release of William O'Brien, MP." Constables, foot guards and life guards waded into the crowd to clear the square. No shots were fired, but fists, feet and clubs killed two people. The protestors' phrase described the tragedy, a term to chill the Irish again and again: "Bloody Sunday."

Shortly after the melee, Angus Thomas released his vitriolic card, "hardly a subject to foster peace and goodwill to all men." His "Christmas" theme featured not the images of St. Nick or a Nativity scene, but a club—a police truncheon. His idea of humor was the following lines about the weapon swung against O'Brien's supporters: "To be used with great care. For external use only."

For the Irish at home or abroad, the card's Yuletide sentiments were appalling:

Ode to the Specials
In Trafalgar Bay where the French men lay,
A Hero was Nelson there!
But nothing was he tho'
King of the Sea.
To the Kings of Trafalgar Square.
With Jack on Watch and with battened hatch.
There France in the pride was quashed.
Washed in the waves where they found a grave—
But they hatton'd "The Great Unwashed!"
Then surely the fame of Nelson's name
The Specials have right to share:
He won the day in Trafalgar Bay
But They in Trafalgar Square
With Best Wishes for a Specially Jolly Christmas

By the time of 1887's "Bloody Sunday," Boston's Irish were a genuine community, slowly amassing clout at the ballot box and bucking Yankee strangleholds on business and the courts. If any in the Irish wards ever needed a reminder that as hard as life in Brahmin Boston could be, their countrymen overseas still faced greater obstacles, the Bloody Sunday "Christmas Card" was vivid proof.

Thankfully, as the nineteenth century drew to a close, Boston's Irish could celebrate Christmas as openly as they wanted, with family parties and dinners, church socials and midnight Mass turning the Yuletide season into a genuine holiday. As Thomas H. O'Connor writes in *Boston Catholics*,

"Boston Catholics participated in a perpetual calendar of familiar religious devotions that…bound them more firmly together as members of their own distinctive parishes."

During the period of Advent in late November and early December, for example, persons of all ages prepared for the coming of the Christmas season by attending daily Mass. They then enjoyed the celebration of midnight Mass on Christmas Eve, often followed by festive and early morning breakfasts with friends and relatives.

Those scenes would have been virtually unthinkable for Boston's earliest Irish immigrants. Yet by the turn of the twentieth century, the Irish openly celebrated the Yuletide as cheerfully as they pleased in the city where Puritans had once banned the holiday and had punished transgressors with fines or the stocks.

Through religion, reflection and revelry, Boston's Irish could finally celebrate Christmas in "grand fashion."

INFANTRY ON THE MARCH.

Sincerest Wishes for a happy Christmas.

Christmas cards crafted by Belfast printer Marcus Ward found their way to Boston in the late nineteenth century. *Hallmark Archives.*

PART ELEVEN

ALL POLITICS IS LOCAL

A Mayoral Milestone
Patrick Collins

On January 4, 1902, Patrick Collins was a proverbial man on a mission. He was sworn in that day as Boston's first Irish mayor of the twentieth century. He had come a long way.

Young Patrick Collins could only cringe on a day in the 1850s as a demented preacher dubbed "the Archangel Gabriel" led a rampaging Yankee mob through Irish Catholic Chelsea. The rioters ripped the cross from the roof of the parish church. Brigands shattered windows and kicked down doors. The mob dragged Irishmen and boys into the street and bloodied them with fists, feet and clubs.

Covering himself up as best he could, young Collins endured his beating—and never forgot it. He would use it as a personal springboard to bring clout to his fellow Boston Irish, like those pounded in Chelsea by "Gabriel" and his "angels."

On March 12, 1844, in County Cork, Patrick Collins was little more than two when the Great Famine ravaged Ireland. His father, weakened by "the Hunger," succumbed to pneumonia before his son ever knew him, and the boy and his widowed mother boarded a "coffin ship" for Boston shortly afterward.

Mother and son settled for several years in Chelsea's ramshackle, disease-riddled tenements. As did most Irish boys his age, Collins learned to scrap against Yankee bullies and those of his own heritage as well. He also learned to read and write in a public school, displaying a quick, facile intelligence.

With college out of the question for a poor immigrant boy, Collins ended up working as a farmhand and a coal miner in Ohio for two years but, in his

teens, returned with his mother to Boston. They took a flat in South Boston. He continued his education on his own, one account asserting that he spent all day learning the upholsterer's trade and all night studying at the Boston Public Library.

By 1864, he had grown into a sturdy young man, "a capable and highly paid [for an Irish tradesman of the day] workman." His bosses and his friends admired his "loyalty to his fellows" and his manner of speech, a winning combination of the proverbial "gift of gab" and a polish obtained through his countless hours of memorizing classic literature and oratory. Many of Collins's fellow immigrants would have been satisfied with the secure, unremarkable life his trade promised. Collins, however, had his eye on far more than that.

Still seething with memories of "the Archangel Gabriel" and other indignities that the Irish endured daily from prejudiced Yankees, Collins intended to get even. His anger also stretched across the Atlantic, back to Ireland. Although he could not recall much of County Cork, "his knowledge of it gained from his elders, must have been colored by the catastrophe of the famine in the midst of which his father died." In Collins's view, Yankee prejudice ranked with "English tyranny."

Collins was a perfect recruit for the local immigrants dreaming of an uprising against the British once the Civil War ended and the Irish wearing Union blue could apply their bloody battlefield lessons against the British. Sometime in 1864, Collins strode into a meeting of the South Boston Fenian Circle and soon established himself as "a man to watch" in the movement. Enflamed with the would-be rebels' anti-British rhetoric, he took a job as a recruiter from Boston to New York. However, in the wake of the Fenians' tragiccomic forays against British-held Canada after the Civil War, disillusionment, as well as a waning interest in revolutionary violence, gripped Collins. He came to the belief that the only way to seize equality was not through bullets, but through the ballot box.

Collins walked in the fall of 1867 into a different sort of meeting—South Boston's Irish Democratic caucus. Already known as a highly intelligent man and a gifted speaker, he was welcomed into the bruising world of Boston politics. He had found his element.

Collins started small by winning a slot as a delegate in the Democratic convention, and in 1868, he rode a wave of Boston Irish votes to the state's House of Representatives, where he quickly riled some Brahmins as a mouthpiece for "the ragged Irish." Collins won reelection and also crashed through a Yankee bastion by earning a Harvard law degree in 1871. Along with attorney Thomas Gargan and fellow immigrant movers and shakers, Collins began crafting a blueprint for Irish political muscle from the wards to the voting booth. So popular was Collins among the local Irish and even

Yankees who grudgingly admired his "up by the bootstraps" work ethic that he was elected to Congress; he loathed Washington, however, always believing he could better serve Boston's Irish in Boston. Finally, in the 1890s, he came back home for good.

Collins's neatly combed and parted hair, bristling mustache and intense eyes were a welcome sight back in the wards. His rhetoric, once blazing with Fenian fury, now delivered a more pragmatic message to immigrants: "There are Irish-born citizens like myself, and there will be many more of us. But the moment the seal of the government was impressed upon our papers, we ceased to be foreigners and became Americans. Americans we are, and Americans we will remain."

In an 1884 speech, he defined what for many Irish Americans would serve as a political credo, reminding listeners that they must never forget their Irish roots, but that they must be assimilated into American life: "Those of us born in Ireland or who sprang from the Irish race are here to stay. We and our children and children's children are here merged in this great, free, composite nationality, true and loyal citizens of the state and federal systems, sharing in the burdens and the blessings of the freest people on the earth."

Still, Collins knew that much work lay ahead before native-born Americans accepted the Irish and that such acceptance would never completely arrive in his lifetime. He was determined, however, to push for that breakthrough.

In 1899, the city's ward leaders convinced Collins to run for the office that many supporters felt was his destiny all along—mayor of Boston. After a clash with Ward Eight titan Martin Lomasney, Collins lost narrowly to Republican Thomas N. Hart, but vowed to run and win two years down the road.

Not only did Collins negotiate a political truce among Lomasney and rival Democratic factions, but he also solidified support from Yankee businessmen and politicians who believed that Collins, despite his Hibernian roots, was conservative enough to be a "bottom-line" mayor. So effective was Collins's "olive branch" approach that voters throughout the city were vying with each other in the desire to be first in line for General Collins.

On election night in November 1901, the Collins-Lomasney "machine" rolled to victory, crushing Hart by the largest margin in Boston's mayoral annals. Oliver Wendell Holmes, chief justice of the Supreme Court, swore in Patrick Collins as Boston's second Irish-born mayor (Hugh O'Brien, in the 1880s, was the first) on January 4, 1902.

Although some of Collins's cronies worried that his once-bullish constitution had ebbed, his performance in the mayor's office belied any ill health. Collins stood up time and again to the Common Council and

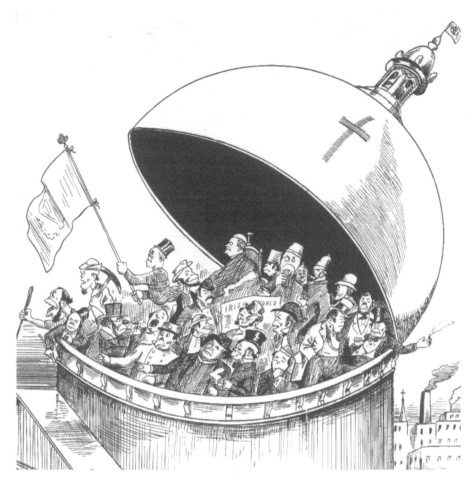

A turn-of-the-century newspaper cartoon lampooning the rising influence of the Irish in Boston politics. *Boston Public Library*.

the Board of Aldermen's "incompetents and nobodies" who had plagued Boston politics by allying "with a mixture of convicts and notorious grafters." When it came to political hardball, Collins proved a master, the local press lauding him as "a strong man and the city's defender against some of the most corrupt schemes that ever menaced it." In 1903, Collins swept back into office on the strength of his honesty and his pledge to usher in an "Era of Good Feeling" for immigrants and bluebloods alike.

Patrick Collins's dream of peaceful coexistence between Boston's Irish Democrats and Yankee Republicans was short-lived. The news that he had died suddenly at the Hot Springs Resort, in Virginia, stunned the city on September 14, 1905.

City Hall, where Hugh O'Brien and Patrick Collins battled their way to the mayor's office. *Boston Public Library.*

For one of the few times in Boston's history to that date, eulogies for the Irishman who had survived the Famine, worked tirelessly to improve himself and the lives of fellow immigrants and had dominated the Boston political scene for years poured in from Yankees as well as the Irish. The *Boston Globe* praised him as "a manly man among manly men, [who]…filled the public office to which he was called with high honor." Another writer called him "the recognized leader of his race."

At Holy Cross Cathedral, Collins's constituents gave him a hero's send-off. Far from the soil of Cork, he was laid to rest near his mother, in Holyhood Cemetery in Brookline.

Boston Mayor Patrick Collins, whose term in office was cut tragically short. *Burns Library, Boston College.*

The city had one more honor to bestow upon "the General" of Boston politics. Spurred by a committee that included both Catholics and Protestants, Bostonians raised funds to create a monument to him. Today, a stately granite memorial graces the Commonwealth Avenue Mall. Before Irish Americans hustle past the bust of Patrick Collins, they should stop for a moment and take a look at his determined visage—that of a man who truly helped put the Irish on Boston's political landscape in the twentieth century.

"Curley Became a Bathhouse and Gallivan a Road…"

James Michael Curley and James Ambrose Gallivan waged bare-knuckles political warfare against each other. Today, however, as countless vehicles head up and down Gallivan Boulevard, few drivers likely give more than a fleeting thought to the artery's namesake. Many might figure that "Gallivan" was a Boston Irish boy made good or perhaps a local man who marched off to war but never returned.

In fact, James Ambrose Gallivan was a man who made headlines in his era in large part because he and "Himself," Curley, tore into each other with fiery bursts of character assassination.

The Irish American whose name adorns today's Dorchester thoroughfare actually hailed from South Boston. His saga began on October 22, 1866, when he was born to James and Mary (Flynn) Gallivan. A bright youth and a gifted athlete, he went to Boston Latin, where he graduated in 1884, winning the Benjamin Franklin medal for his academic prowess.

Gallivan's affinity for the books led to Harvard, where he would make a notable mark. According to the *New York Times*, "Besides being an able scholar, he was so proficient as a second baseman [some accounts say first baseman] that the big leagues were open to him when he gained his bachelor's degree in 1888. Instead, he became a newspaper reporter."

As a reporter, Gallivan learned the ins and outs of the raucous ward politics of late nineteenth-century Boston, and he decided to enter, rather than just observe, the political action in 1895. The twenty-nine-year-old Gallivan ran for the state representative's post from South Boston and won. His days as a newspaperman were over.

Congressman James Ambrose Gallivan, who waged a vicious campaign against James M. Curley for mayor of Boston. *Dorchester Reporter*.

Within three years, Gallivan had claimed a seat in the Massachusetts Senate, earning the spot of minority leader. He served as street commissioner of Boston from 1900 to 1914 and, in the fall of 1914, was elected to Congress as a Democratic representative to fill the vacancy caused by the resignation of James M. Curley, now the mayor of Boston.

Gallivan made his presence known in Washington as one of the most flamboyant members of the House. He was one of the so-called "Wet Bloc," legislators opposing the Temperance movement's snowballing crusade to ban "demon alcohol" in every corner of the nation. In 1918, Gallivan began listening to Boston friends who urged him to run for another office—the

one currently held by "Himself," Mayor Curley. There was little question that Gallivan could carry a large share of the Irish vote, especially in South Boston, where his wife, the former Louise Burke, had also been raised.

The 1918 mayoral election proved one of the most rancorous and most memorable in the city's annals as Curley was challenged by Gallivan, "Honey Fitz" Fitzgerald's man; Peter Teague, another congressman and the choice of "the Mahatma," powerful ward boss Martin Lomasney; and Yankee politician Andrew J. Peters. Gallivan, assessing his chances against Curley, contended, "I'll tear the hide off him."

On the campaign stump, Gallivan chided the patronage of Curley and asked, "Who put the 'plum' in plumbing?" The reference was to Curley cronies who had been awarded lucrative city contracts.

Curley responded with verbal blasts that Gallivan was "a desperado of American politics," an "egotist" and a "slacker." The incumbent charged that Gallivan was a congressman who should attend to his duties in Washington rather than run for mayor of Boston: "Will Gallivan be in the nation's capital…when the bill for national prohibition is considered?" asked Curley.

A Gallivan ad in the *Boston Post* countered that Curley "stands for the worst things in American politics." In turn, Curley derided Gallivan as a "Hessian" and "jitney [period slang for a bus or van] messiah." Curley also claimed that there was a good reason for Gallivan's opposition to the proponents of temperance: "I thought it might be providential to call the attention of the electorate to Jimmy's elbow-bending." The tactic fell utterly flat, as Curley would acknowledge.

When the votes were tallied, neither Gallivan nor Curley emerged the victor. Peters, with the other candidates carving up the Democratic vote, won the election.

Curley, in his memoir, gave Gallivan a few nods: "Gallivan was a colorful character…He was a great campaigner, and during World War One, when he thought General Pershing was unfair to the officers of the Yankee Division, composed of New England troops, he [Gallivan] denounced him and called the War Department 'the typewriter brigade safely housed behind the lines.'"

The local voters who had come out for Gallivan in his failed mayoral gambit returned him to Washington again and again as the congressman from the Massachusetts Twelfth District. His often boisterous debating style earned him a formidable reputation on the floor of the House and, in all probability, his friends and foes alike attributed his bout with laryngitis in March 1928 as an "occupational hazard" for him. Then, colleagues noticed something else: the characteristically vigorous politician was visibly fatigued.

James Michael Curley, "Himself," who skewered Gallivan on the stump and in print. *Boston Herald.*

Against the advice of his Washington physicians, Gallivan took a train to visit Boston in late March 1928. Shortly after his arrival, his local doctor, Edward Denning, suggested that the congressman check into the Ring Hospital in Arlington "for rest and observation." Gallivan agreed.

Following dinner at the hospital with his secretary, James A. Urich, on April 3, 1928, the congressman remarked that "he felt all right except that he was exhausted." He went to bed early, and when a nurse checked in on him at 5:15 a.m. on April 4, the sixty-two-year-old Gallivan was sleeping soundly. Half an hour later, the nurse discovered that the politician was dead. His passing was attributed to underlying heart disease.

At the news of Gallivan's death, the House members adjourned their April 8 session "out of respect to his memory." The *New York Times* noted, "Expressions of regret over his passing were voiced at the White House and among leaders generally, regardless of political affiliation."

President Calvin Coolidge, a former Massachusetts governor, sent Mrs. Louise Gallivan a note of condolence: "I have heard with deep regret of the sudden death of Representative Gallivan, and I wish to extend to you my sympathies. He was sincerely devoted to the interests of his district and his State, and his passing is a real loss to the Commonwealth."

Congressman James Gallivan's funeral Mass was at St. Augustine's in South Boston, and he was buried in St. Joseph's Cemetery in West Roxbury. A fitting bit of local immortality awaited the one-time street commissioner of Boston.

In the days after his death in early April 1928, the name of Congressman James A. Gallivan was much on the minds of local, as well as national, politicians. The eulogies from Boston to Washington continued to pour in, and some of the men with whom Gallivan had gone toe to toe in bruising bare-knuckle elections might well have wondered if the man mentioned in all the paeans was the same Jim Gallivan they knew, the same Jim Gallivan just laid to rest in St. Joseph's Cemetery in West Roxbury.

Locals on Gallivan's electoral turf—especially in South Boston—saw the praise as only fitting, as for most in Southie, Gallivan had been "their guy." No one was surprised at the plaudits that came his way from his good friend U.S. Senator David Walsh, a former governor of Massachusetts. Proving the old adage that "all is forgiven in death," Republican Congressman Allen T. Treadway, the dean of the Massachusetts delegation, spoke in laudatory terms of Gallivan from both the well of the House and in the newspapers. In many ways, the closest they had been on political terms was the fact that Treadway ranked first in number of terms for the Massachusetts delegation in the House, Gallivan second.

Back in Boston, a legion of Gallivan's friends, neighbors and supporters began casting about for ways to memorialize him. The question was how.

While Gallivan had proven an effective legislator, he had also sparked controversy—especially on the Prohibition issue. From the start, he had waged a political war against the "dry law," a stance that had not hurt him much among local male voters, but had earned him the enmity of many women who had been among the most vociferous proponents of Prohibition. His old foe James Michael Curley had acknowledged that Gallivan was a fierce and effective campaigner who had two chief talents: the first was a knack for "unholy tactics [that] succeeded in stirring the passions of the mob." As locals knew and loved or reviled Curley as the man who helped write the proverbial book on political mudslinging, the charge did not cause much of a political ripple. The second contention, one that Curley had raised during the free-for-all that had been the 1918 mayoral election, was rooted in Gallivan's unyielding opposition to the Temperance movement.

As Curley would have it, during the rancorous 1918 campaign,

> *I thought it might be providential to call the attention of the electorate to Jimmy's elbow-bending. Congressman Gallivan has two degrees. One from Harvard and one from the Washington Institute for Dispsomaniacs* [someone with a craving for alcohol]. *As you know, the hotel rooms in which Congressmen live in Washington have bells that could summon members of the House to a roll-call vote. Unfortunately, the pubs and taverns in Baltimore frequented by my opponent are not equipped with bells, which accounts for Gallivan's impressive absentee record.*

Gallivan had parried, "I have stopped off in the fair city of Baltimore only twice. On one occasion…to shake the hand of Cardinal Gibbons, who said he wanted to meet a person who wasn't afraid to stand on the floor of Congress and defend the faith. The other time was to address…the Knights of Columbus."

Since Galvin's career had not featured a record of heroic or earth-shaking achievements, his friends would have had a hard time getting a statue built in his honor. There were other ways, however, to honor their man. As he had served as Boston's street commissioner from 1900 to 1914, his supporters looked for a bridge or a stretch of roadway they might name after him. Shortly after his funeral, their collective gaze turned toward Marsh and Codman Streets in Dorchester.

That same year, the city of Boston joined the two Dorchester Streets—a project that had been in the works—paved them to handle increased traffic and renamed them Gallivan Boulevard. No one—even those who had despised Gallivan—could really argue that a project had been

rubberstamped simply to honor him. Of the site chosen, a Dorchester resident noted, "When we first came here, Gallivan Boulevard had been recently made. It was originally Codman Street. On the left hand side of Gallivan Boulevard, there was a swamp. In the thirties they built homes there. Before that it was all just one big swamp."

To those who viewed Massachusetts politics of Gallivan's day as a swamp, the image may well have seemed apt. Later, a political observer would joke that in the end, after all the campaign battles, Curley became a bathhouse and Gallivan a road.

Sources

Author's Note: Essential sources for the book included the many newspapers and periodicals in and around Boston from the 1700s to the present. Within the chapters, these sources are cited.

Adams, William. *Ireland and Irish Immigration to the New World from 1815 to the Famine*. New Haven, 1932.

Ainley, Lesley. *Boston Mahatma: Martin Lovmasney*. Boston, 1949.

Ames, Seth, ed. *The Works of Fisher Ames*. 2 vols. Boston, 1854.

Bailey, Ronald, et al. *Lower Roxbury: A Community of Treasures in the City of Boston*. Boston, 1993.

Barrett, J.R. "Why Paddy Drank: The Social Importance of Whiskey in Pre-Famine Ireland." *Journal of Popular Culture* 11 (1977): 155–66.

Baum, Dale. *The Civil War Party System: The Case of Massachusetts, 1848–1876*. Chapel Hill, NC, 1984.

———. "The 'Irish Vote' and Party Politics in Massachusetts, 1848–1876." *Civil War History* 26 (1980): 117–41.

Beals, Carleton. *Brass Knuckle Crusade: The Great Know-Nothing Conspiracy, 1820–1860*. New York, 1960.

Bean, William G. "Puritan Versus Celt, 1850–1860." *New England Quarterly* 7 (1934): 81–92.

Beatty, Jack. *The Rascal King: The Life and Times of James Michael Curley, 1874–1958*. Reading, MA, 1992.

Billington, Ray Allen. *The Protestant Crusade, 1800–1860*. New York, 1938.

Blodgett, Geoffrey. "Yankee Leadership in a Divided City." In *In Boston, 1700–1980: The Evolution of Urban Politics*, edited by Ronald Formisano and Constance Burns. Westport, CT, 1984.

Bridenbaugh, Carl. *Cities in Revolt: Urban Life in America, 1743–1776*. New York, 1955.

———. *Cities in the Wilderness: Urban Life in America, 1625–1742*. New York, 1938.

Brown, Richard D. *Massachusetts: A Bicentennial History*. New York, 1978.

Brown, Thomas N. *Irish-American Nationalism, 1870–1890*. Philadelphia, 1966.

Burton, William L. "Irish Regiments in the Union Army: The Massachusetts Experience." *Historical Journal of Massachusetts* (June 1983): 104–15.

Cook, Adrian. *The Armies of the Streets: The New York City Draft Riots of 1863*. New York, 1974.

Cullen, James B. *The Story of the Irish in Boston*. Boston, 1889.

Curley, James Michael. *I'd Do It Again: A Record of All My Uproarious Years*. Englewood, NJ, 1957.

Curran, Michael P. *The Life of Patrick Collins*. Norwood, MA, 1906.

Dezell, Maureen. *Irish America: Coming into Clover*. New York, 2001.

Diner, Hasia. *Erin's Daughters in America: Irish Immigrant Women in the Nineteenth Century*. Baltimore, 1983.

Dinneen, Joseph F. *The Purple Shamrock: The Hon. James Michael Curley of Boston*. New York, 1949.

Erie, Steven P. *Rainbow's End: Irish Americans and the Dilemma of Urban Machine Politics, 1840–1985*. Berkeley, CA, 1988.

Gallagher, Thomas. *Paddy's Lament: Ireland, 1846–1847*. New York, 1982.

Galvin, John T. "The 1925 Campaign for Mayor was a Four-Ring Circus." *Boston Sunday Globe*, August 21, 1983.

————. "Boston's Eminent Patrick from Ireland." *Boston Globe*, March 17, 1988.

————. "Boston's First Irish Cop." *Boston Magazine*, March 1975.

————. "The Dark Ages of Boston Politics." *Proceedings of the Massachusetts Historical Society* 89 (1977): 88–111.

————. "The Mahatma Called the Shots and Everyone Knew It." *Boston Globe*, June 4, 1990.

————. "The Mahatma Who Invented Ward 8." *Boston Magazine*, November 1975.

————. "Patrick Maguire: Boston's Last Democratic Boss." *New England Quarterly* 55 (1982): 392–416.

————. "There's Some Irish Green in the Brahmins' Blue Blood." *Boston Globe*, March 17, 1989.

————. "When the Irish Made It to City Hall." *Boston Globe*, December 7, 1984.

Goodwin, Doris Kearns. *The Fitzgeralds and the Kennedys: An American Saga*. New York, 1987.

Green, James, and Hugh Donahue. *Boston's Workers: A Labor History*. Boston, 1979.

Griffin, William D. *The Book of Irish Americans*. New York, 1990.

Hale, Edward Everett. *Letters on Irish Emigration*. Boston, 1852.

Haltigan, James. *The Irish in the American Revolution and Their Early Influence in the Colonies*. Washington, D.C., 1907.

Handlin, Oscar. *Boston's Immigrants*. Cambridge, MA, 1941.

Hanna, William F. "The Boston Draft Riot." *Civil War History* 36 (September 1990): 262–73.

Hart, Albert B. *Commonwealth History of Massachusetts*. 5 vols. New York, 1927–1930.

Hennesey, James. *American Catholics: A History of the Roman Catholic Community in the United States*. New York, 1981.

Higgins, Nathan. *Protestants Against Poverty: Boston's Charities, 1870–1900*. Westport, CT, 1971.

Higham, John. "The Mind of a Nativist: Henry F. Bowers and the A.P.A." *American Quarterly* 4 (1952): 16–24.

Hillson, Jon. *The Battle of Boston*. New York, 1977.

Hodgkinson, Harold D. "Miracle in Boston." *Proceedings of the Historical Society* 84 (1972): 71–81.

Hofstadter, Richard. *The Paranoid Style in American Politics*. Chicago, 1979.

Holmes, Oliver Wendell. *Elsie Venner*. Boston, 1847.

Horton, James O., and Lois E. Horton. *Black Bostonians Family Life and Community Struggle in the Antebellum North*. New York, 1979.

Houston, Amanda V. "Beneath the El." *Boston College Magazine* (Summer 1988): 20–25.

Imminent Dangers to the Free Institutions of the United States Through Foreign Immigration. New York, 1854.

Jaher, Frederic Cople. "The Boston Brahmin in the Age of Industrial Capitalism." In *The Age of Industrial Capitalism in America*, edited by F.C. Jaher. New York, 1968.

Johnson, Paul. *The Birth of the Modern: World Society, 1815–1830*. New York, 1991.

Kane, Paula M. *Separatism and Subculture: Boston Catholicism, 1900–1920*. Chapel Hill, NC, 1994.

Katz, Michael B. *The Irony of Early School Reform: Educational Innovation in Mid-Nineteenth Century Massachusetts*. Boston, 1968.

Kennedy, Lawrence W. *Planning the City Upon a Hill: Boston Since 1630*. Amherst, MA, 1992.

King, Mel. *Chain of Change: Struggles f or Black Community Development*. Boston, 1981.

Kleppner, Paul. "From Party to Factions: The Dissolution of Boston's Majority Party, 1876–1908." In *Boston, 1700–1980: The Evolution of Urban Politics*, edited by Ronald Formisano and Constance Burns. Westport, CT, 1984.

Knolbe, Dale T. *Paddy and the Republic: Ethnicity and Nationality in Antebellum America*. Middletown, CT, 1986.

Kurtz, Stephen G. *The Presidency of John Adams: The Collapse of Federalism, 1795–1800*. Philadelphia, 1957.

Lader, Lawrence. *The Bold Brahmins: New England's War against Slavery, 1830–1863*. New York, 1961.

Lane, Roger. *Policing the City: Boston, 1822–1885*. New York, 1971.

Lapomarda, Vincent A. "Maurice Joseph Tobin, 1902–1953: A Political Profile and an Edition of Selected Public Papers." PhD diss., Boston University, 1968.

Leach, Jack. *Conscription in the United States*. Rutland, VT, 1952.

Leckie, Robert. *American and Catholic*. New York, 1970.

Lee, Basil. *Discontent in New York City, 1861–1865*. New York, 1941.

Levin, Murray. *The Alienated Voter: Politics in Boston*. New York, 1960.

Levine, Edward M. *The Irish and Irish Politicians: A Study of Cultural and Social Alienation*. Notre Dame, 1966.

Levine, Hillel, and Lawrence Harmon. *The Death of an American Jewish Community: A Tragedy of Good Intentions*. New York, 1992.

Lodge, Henry Cabot. *The Story of the Revolution*. New York, 1898.

Lord, Robert H., John E. Sexton and Edward Harrington. *History of the Archdiocese of Boston*. 3 vols., Boston, 1945.

Lupo, Alan. *Liberty's Chosen Home: The Politics of Violence in Boston*. Boston, 1977.

Luthin, Reinhard H. *The First Lincoln Campaign*. Cambridge, MA, 1944.

Lyell, Sir Charles. *A Second Visit to the United States of North America*. 2 vols. New York, 1849.

Malliam, William D. "Butlerism in Massachusetts." *New England Quarterly* 33 (1960): 186–206.

Mann, Arthur. *Yankee Reformers in the Urban Age: Social Reform in Boston, 1880–1900*. New York, 1954.

Marquand, John P. *The Late George Apley*. New York, 1936.

Maxwell, John Francis. *Slavery and the Catholic Church*. London, 1975.

McMaster, John Bach. *A History of the People in the United States from the Revolution to the Civil War.* 8 vols. New York, 1906.

Mehegan, David. "The New Bostonians." *Boston Globe Magazine*, January 3, 1982, 12–15.

Meister, Richard J., ed. *Race and Ethnicity in Modern America.* Lexington, MA, 1974

Melville, Annabelle M. *Jean Lefebvre de Cheverus, 1768–1836.* Milwaukee, 1958.

Meyers, Gustave. *History of Bigotry in the United States.* New York, 1941.

Meyers, Marvin. *The Jacksonian Persuasion: Politics and Relief.* Palo Alto, CA, 1957.

Miller, John C. *The Federalist Era, 1789–1801.* New York, 1960.

Miller, Kerby. *Emigrants and Exiles: Ireland the Irish Exodus to North America.* New York, 1985.

Mollenkopf, John H. *The Contested City.* Princeton, NJ, 1983.

Montgomery, David. *Beyond Equality: Labor and the Radical Republicans.* New York, 1967.

Morrison, Samuel Eliot, ed. *Builders of the Bay Colony.* Boston, 1981.

―――. *A History of the Constitution of Massachusetts.* Boston, 1917.

―――. *The Life and Letters of Harrison Gray Otis, Federalists 1765–1848.* 2 vols. Boston, 1913.

―――. *The Maritime History of Massachusetts, 1783–1860.* Boston, 1921.

Morse, Samuel F.B. *Foreign Conspiracy against the Liberties of the United States.* New York, 1836.

Mulkern, John R. *The Know-Nothing Party in Massachusetts: The Rise and Fall of a People's Party.* Boston, 1990.

―――. "Scandal Behind the Convent Walls: The Know-Nothing Nunnery Committee of 1855." *Historical Journal of Massachusetts* 2 (1983): 22–31.

Murdock, Eugene. *One Million Men: The Civil War Draft in the North.* New York, 1971.

―――. *Patriotism Unlimited: The Civil War Draft and the Bounty System.* New York, 1967.

Nolan, Martin F. "Exit the Irish: A Hushed Last Hurrah." *Boston Globe*, November 3, 1993.

O'Brien, Michael J. *The Irish at Bunker Hill*. Shannon, Ireland, 1968.

O'Connor, Thomas H. *Bibles, Brahmins, and Bosses: A Short History of Boston*. 3rd ed. Boston, 1991.

————. *Building a New Boston: Politics and Urban Renewal, 1950–1970*. Boston, 1993.

————. *Fitzpatrick's Boston, 1846–1866: John Bernard Fitzpatrick, Third Bishop of Boston*. Boston, 1984.

————. "The Irish in New England." *New England Historical and Genealogical Register* 139 (July 1985): 187–95.

————. "Irish Votes and Yankee Cotton: The Constitution of 1853." *Proceedings of the Massachusetts Historical Society* 95 (1983): 88–99.

————. *Lords of the Loom: The Cotton Whigs and the Coming of the Civil War*. New York, 1968.

————. *South Boston: My Home Town*. Boston, 1988.

O'Connor, Thomas H., and Alan Rogers. *Boston Catholics: A History of the Church and Its People*. Boston, 2000.

————. *Civil War Boston: Home Front and Battlefield*. Boston, 1998.

————. *This Momentous Affair: Massachusetts and the Ratification of the Constitution of the United States*. Boston, 1987.

O'Donnell, Edward T. *1001 Things Everyone Should Know About Irish American History*. New York, 2006.

O'Hare, M. Jeanne d'Arc. "The Public Career of Patrick Collins." PhD diss., Boston College, 1959.

O'Toole, James M. *Militant and Triumphant: William Henry O'Connell and the Catholic Church in Boston, 1859–1944*. Notre Dame, IN, 1992.

————. "'The Newer Catholic Races': Ethnic Catholicism in Boston, 1900–1940." *New England Quarterly* 65 (1992): 117–34.

———. "Prelates and Politicos." In *Catholic Boston: Studies in Religion and Community, 1870–1970*, edited by Robert E. Sullivan and James M. O'Toole. Boston, 1985.

Palfrey, John Gorham. *A History of New England.* Boston, 1865.

Parkman, Francis: *Our Common Schools.* Boston, 1890.

Pessen, Edward. *Jacksonian America.* Urbana, IL, 1969.

Potter, George. *To the Golden Door.* Boston, 1960.

Quinlin, Michael. *Irish Boston: A Lively Look at Boston's Colorful Past.* Guilford, CT, 2004.

Rice, Madeleine Hooke. *American Catholic Opinion in the Slavery Controversy.* Gloucester, MA, 1964.

Robinson, William S. *"Warrington" Pen Portraits.* Boston, 1877.

Russell, Francis. *City in Terror: 1919, the Boston Police Strike.* New York, 1975.

———. *The Knave of Boston and Other Ambiguous Massachusetts Characters.* Boston, 1987.

Ryan, Dennis P. *Beyond the Ballot Box: A Social History of the Boston Irish, 1845–1917.* Amherst, MA, 1989.

Samito, Christian. *Commanding Boston's Irish Ninth: The Civil War Letters of Colonel Patrick R. Guiney.* New York, 1997.

Sanders, James W. "Catholics and the School Question in Boston: The Cardinal O'Connell Years." In *Catholic Boston: Studies in Religion and Community, 1870–1970*, edited by Robert E. Sullivan and James M. O'Toole. Boston, 1989.

Schabert, Tilo. *Boston Politics: The Creativity of Power.* Berlin, 1989.

Schlesinger, Arthur B., Jr. *The Age of Jackson.* Boston, 1945.

Schultz, Stanley K. *The Culture Factory: Boston Public Schools, 1789–1860.* New York, 1973.

Schwartz, Harold. "Fugitive Slave Days in Boston." *New England Quarterly* 27 (1954): 191–212.

"Shamrocks and Shillelaghs: The Phenomenon of Ethnic Mayors in Boston Politics." *Forum 350*, John F. Kennedy Library, Boston, September 16, 1980.

Shannon, William V. *The American Irish.* New York, 1966.

Shapiro, Samuel. "The Conservative Dilemma: The Massachusetts Constitutional Convention of 1853." *New England Quarterly* 3 (1960): 207–24.

Solomon, Barbara M. *Ancestors and Immigrants: A Changing New England Tradition.* Cambridge, MA, 1956.

Stack, John F., Jr. *International Conflict in an American City: Boston's Irish, Italian, and Jews, 1934–1944.* Westport, CT, 1979.

Stevenson, Louise. "Women Anti-Suffragists in the 1915 Massachusetts Campaign." *New England Quarterly* 52 (1979): 80–93.

Strahinich, John. "Only Irish Need Apply." *Boston Magazine,* March 1993.

Sullivan, Robert E., and James M. O'Toole, eds. *Catholic Boston: Studies in Religion and Community, 1870–1970.* Boston, 1985.

Tager, Jack. "The Massachusetts Miracle." *Historical Journal of Massachusetts* 19 (Summer 1991): 111–32.

———. "Urban Renewal in Boston." *Historical Journal of Massachusetts* 21 (Winter 1993): 1–32.

Teaford, Jon. *The Rough Road to Renaissance: Urban Revitalization in America, 1940–1984.* Baltimore, 1990.

———. *Unheralded Triumph: City Government in America, 1870–1900.* Baltimore, 1984.

Thernstrom, Stephen. "Urbanization, Migration, and Social Mobility in Late Nineteenth-Century America." In *American Urban History,* 2d ed., edited by Alexander Callow, New York, 1973.

Thompson, E.P. *The Making of the English Working Class.* New York, 1963.

Thompson, Margaret. "Ben Butler versus the Brahmins: Patronage and Politics in Early Gilded Age Massachusetts." *New England Quarterly* 55 (1982): 163–86.

Trout, Charles H. *Boston, the Great Depression, and the New Deal.* New York, 1977.

Tucker, Robert W., and David C. Hendrickson. *Empire of Liberty: The Statecraft of Thomas Jefferson.* New York, 1990.

Walkin, Edward. *Enter the Irish-American.* New York, 1976.

Walsh, Francis R. "The *Boston Pilot* Reports the Civil War." *Historical Journal of Massachusetts* 9 (June 1981): 5–16.

———. "John Boyle O'Reilly, the *Boston Pilot*, and Irish-American Assimilation, 1870–1890." In *Massachusetts in the Gilded Age*, edited by Jack Tager and John Ifkovic. Amherst, MA, 1985.

Walsh, James B. *The Irish America's Political Class.* New York, 1976.

Wangler, Thomas E. "Catholic Religious Life in Boston in the Era of Cardinal O'Connell." In *Catholic Boston: Studies in Religion and Community, 1870–1970*, edited by Robert E. Sullivan and James M. O'Toole. Boston, 1985.

Ward, John William. "The Common Weal and the Public Trust." *Forum 350*, John F. Kennedy Library, Boston, October 21, 1980.

Warner, Sam Bass, Jr. *Streetcar Suburbs: The Process of Growth in Boston, 1870–1900.* New York, 1974.

Warner, W. Lloyd, and Leo Srole. *The Social Systems of American Ethnic Groups.* New Haven, CT, 1954.

Wayman, Dorothy. *Cardinal O'Connell of Boston: A Biography of William Henry O'Connell, 1859–1944.* New York, 1955.

Weinstein, Irving. *July 1863: The Incredible Story of the Bloody New York Draft Riots.* New York, 1952.

Wells, Wellington. "Political and Governmental Readjustments, 1865–1889." Vol. 4 in *Commonwealth History of Massachusetts*, edited by Albert B. Hart. New York, 1930.

White, Anna MacBride, and A. Norman Jeffares, eds. *The Gonne-Yeats Letters, 1893–1938: Always Your Friend.* London, 1992.

White, Patrick C.T. *A Nation on Trial: America and the War of 1812.* New York, 1965.

Whitehill, Walter Muir. *A Topographical History.* Cambridge, MA, 1968.

Wittke, Carl. *The Irish in America.* Baton Rouge, 1956.

Woodham-Smith, Cecil. *The Great Hunger: Ireland, 1848–1849.* New York, 1962.

Zaitzevsky, Cynthia. *Frederick Law Olmsted and the Boston Park System.* Cambridge, MA, 1982.